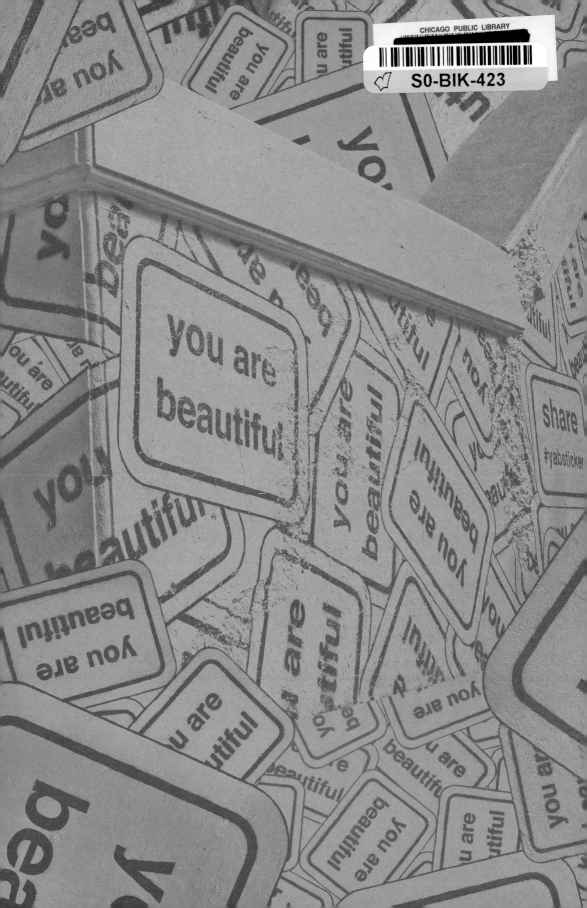

This book is dedicated to you. ●

A DECADE OF YOU ARE BEAUTIFUL

Matthew Hoffman | Chicago, IL
You-Are-Beautiful.com

DESIGN

Firebelly Design | Chicago, IL

EDITING

Johnny Michael, Ben Skoda & Kat Mason

PUBLISHER

Hey It's Matthew | Chicago, IL

PRINTER

Printed by The Avery Group at Shapco
Printing, Inc., MN

FIRST PRINTING

2013
ISBN 978-0-9908186-0-1

- You Are Beautiful is the little sticker that started a worldwide phenomenon. This message, spread by the community, has touched lives on every continent in the world (including Antarctica). It began simply with 100 stickers printed in 2002 in Chicago, and has since evolved into block-long murals, public installations, and exhibitions at cultural institutions involving thousands of artists. You Are Beautiful has been translated into over 30 languages, with over a million stickers circulating around our globe. What happens with the next million is up to you. Grab a handful of stickers, and share this message with your world.

I moved from a small town to Chicago at the age of 23, and was blown away by what the city had to offer. It was incredible and overwhelming at the same time. I was full of wonder and possibilities, and never wanted to lose that drive. I didn't quite know how to explain it, but I wanted to make life better for myself, and everyone around me. So I started putting up this little message everywhere. And do you know the first question almost everyone asks? "Why?" The question baffles me. My immediate response is "Why not?" It just makes sense.

Let's shift the mindset from "why" to "why wouldn't I?"

Life can beat the audacity out of you. Experiences can take away your passion and drive. There is so much negativity in the world — I'm simply not going to add to it. In fact, I'm going to be a force against it. I really enjoy silently and stealthily giving people moments. Just giving them. Moments to be with themselves. Moments to drop all the baggage and ignore what everyone else thinks. A moment to breathe a sigh of relief.

There have been so many times in my life that people have been caring and thoughtful to me, even when I didn't deserve it. It was their generosity that gave me the insight to know how to give to others.

Let's do things like this so often that it doesn't seem odd. Let's be human to each other. Let's be surprisingly generous (and look for nothing in return). Don't try to do it all tomorrow, but start today. Start small, even if it's just one person, one moment — it can make a lasting impact. Let's shift the mindset from "why" to "why wouldn't I?"

Within these pages you'll find the stories and lessons learned over the past decade. This is just a snippet, as we pored through over 30,000 files, photos, and memories. It's been fascinating to reminisce, looking back at how this message has spread. The biggest lesson learned: This isn't something I have to do. This is something I get to do.

As you read these stories, keep in mind that this is not a "how to" guide, but an example of what one group of people was able to accomplish. It's one path, and yours will be unique. Take all of this in, learn from it, and take it even a step further. I can't wait to read your book in ten years.

ANY

GOING

YOUR B

ACTIO

AN

START

KEEP

PUT

TAKE

CREATE

START

As long as it's

anywhere

START ANYWHERE... AS LONG AS IT'S NOW

You're brimming with ideas to share with the world, but if you keep waiting for the perfect moment, you'll be waiting forever. Start now, right now. Make a decision to share yourself with the world.

Close the book, and go do it. Now.

"Measure twice and cut once"...but eventually you have to cut the board. If it doesn't work out, you can always go get another piece of wood. It's better to buy an extra board than to be standing around staring at your ruler, waiting forever to make the next move.

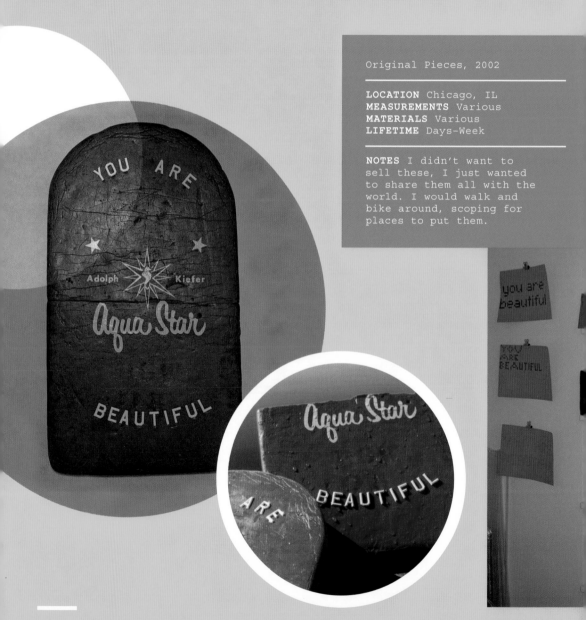

Original Pieces, 2002

LOCATION Chicago, IL
MEASUREMENTS Various
MATERIALS Various
LIFETIME Days-Week

NOTES I didn't want to sell these, I just wanted to share them all with the world. I would walk and bike around, scoping for places to put them.

Any action is better than no action.
You have to put yourself and your
ideas into the world. It doesn't have
to be perfect or completely figured
out. Just get it out there and see what
happens. React, refine, and rework.
Test your ideas in the real world, and
watch how things unfold.

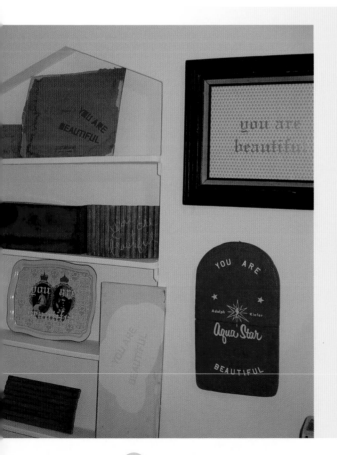

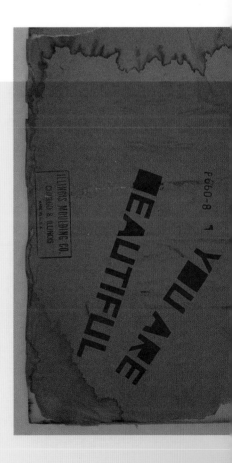

I didn't know what I was doing, but I had an idea. I was sitting at my computer browsing "custom stickers." I came across a discount printing site and they had one option: business card size. The total order would be around $70, plus shipping. I was telling a friend about the idea, and he said he'd give me half to make this idea come into reality.

I have never done anything alone. I have always had a shoulder to lean on, a helping hand, and tons of laughter.

I ordered 100, and two weeks later a tiny stack of stickers tied up in a rubber band arrived. They looked terrible. The stickers were supposed to be green to match the color of light posts, instead they were a muddy brown. They were non-waterproof paper stickers, and they barely stuck. I requested a reprint, but the second batch was worse than the first.

Blue Vinyl, 2007

LOCATION Philadelphia, PA;
 New York City, NY;
 Chicago, IL
MEASUREMENTS 22"×56"
MATERIALS Vinyl
LIFETIME Months–Year

NOTES These low tack vinyl pieces acted much like giant stickers. The vinyl could be easily peeled off, but a few that were placed on abandoned storefronts lasted over a year.

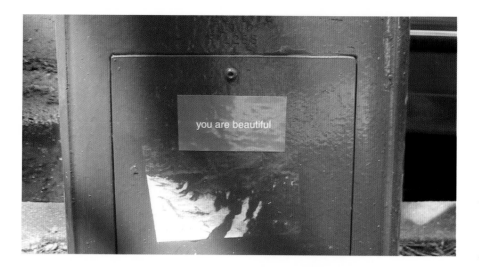

Test your ideas in
the real world.

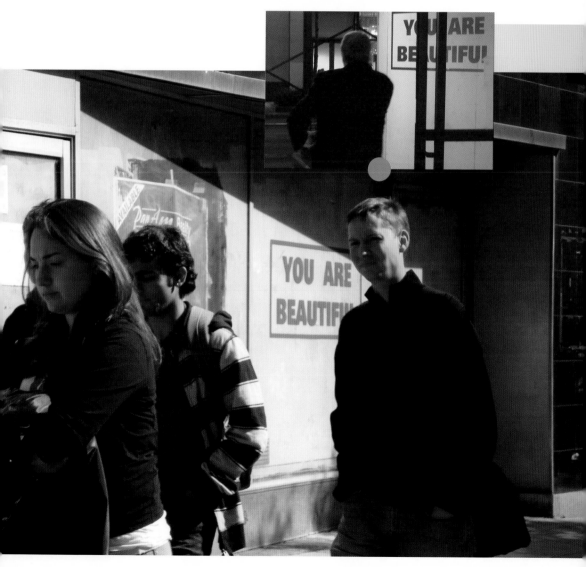

- **Keep pushing yourself, and see what you can do.** Don't get hung up, so worried about how it's going to turn out. Realize that you'll learn, do what you think is best in the moment, and vow to do even better the next time.

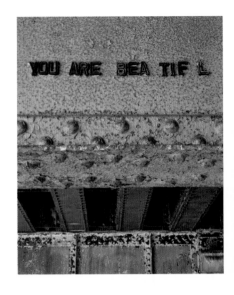

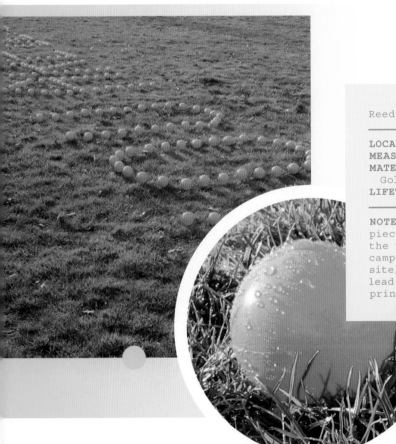

Reed College, 2005

LOCATION Portland, OR
MEASUREMENTS Various
MATERIALS Yard Signs,
 Golf-Tees, Ball-Pit Balls
LIFETIME One-Week

NOTES We came up with many
pieces to work on within
the various aspects of the
campus. We worked a lot on-
site, and also had enough
lead time to have custom
printed signs made.

With a few fridge magnets from a second-hand store and a tube of liquid nails in the freezing cold, an idea was born. It wasn't a smooth process, and it almost didn't happen. Before I left for my adventure, I stared at the partial sentences on the floor in my apartment, knowing just how unimpressive and small they were.

I started to second guess myself, thinking it wasn't worth it. I said, "No, it's now." I ran to the hardware store, bought a tube of glue, and awkwardly stuck these up. I really didn't think they'd last the night.

As it turns out, this start (as unimpressive as it was) was still a start — and has lasted well over a decade in the Rogers Park neighbor-hood of Chicago.

Start small, as long you start today.

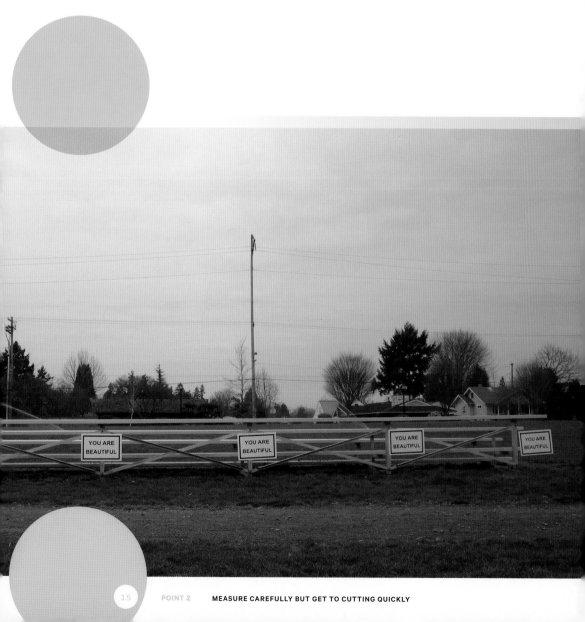

• **Act now, move quickly, and be nimble. Light up your own path and see where it takes you. You don't need to wait for permission or for someone to invite you. Be your own driving force. Make your own possibilities and jump on moments of opportunity along the way.**

Some days, it's nice to be reminded …

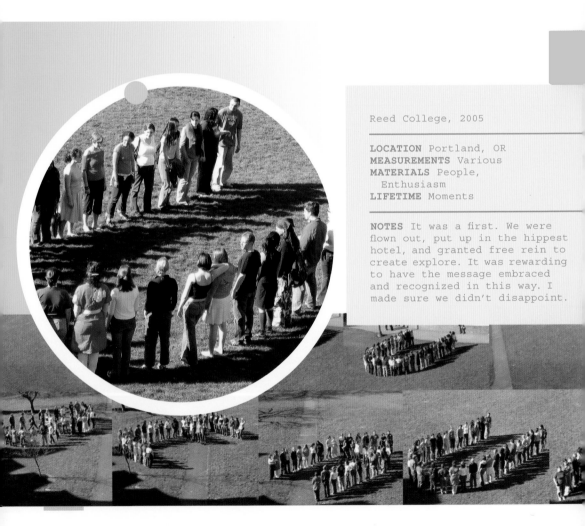

Reed College, 2005

LOCATION Portland, OR
MEASUREMENTS Various
MATERIALS People,
 Enthusiasm
LIFETIME Moments

NOTES It was a first. We were flown out, put up in the hippest hotel, and granted free rein to create explore. It was rewarding to have the message embraced and recognized in this way. I made sure we didn't disappoint.

In 2004, I received an email from Jacob. He and a crew of his friends had walked to an overpass in San Francisco, California. They were equipped with only party streamers and a mission. The installation was only up for an afternoon, but it made quite an impact (and the front page of the Bay Area section of The Sunday Times).

Jacob recalled that while they were working, a police cruiser pulled up and asked them what they were doing. Because of the positive message, the officer said they would just need to return later in the day to take it down.

I was blown away — I had never even considered this. I had always wanted the project to be open source. The fact that someone had been so inspired to take ownership of the message and run with it was incredible. I showed it to a few people, and their response was, "You're cool with them stealing your idea?" I had to explain that the more people that saw the message, the better it would be for everyone.

I created a section on the website dedicated to the community and sharing the message. That's how it started — and this simple message began to spread organically.

I was blown away. I had always wanted the project to be open source.

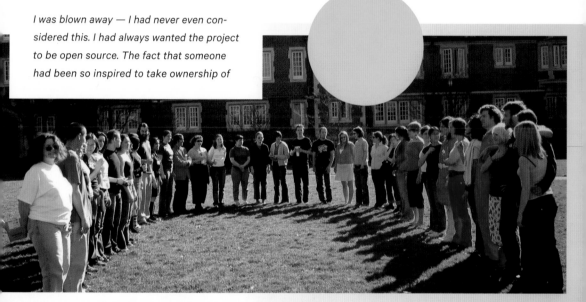

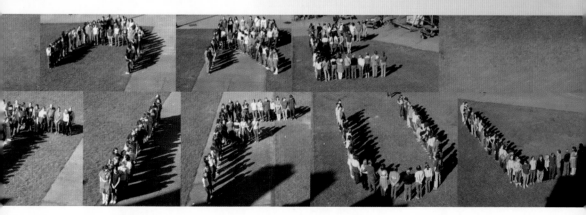

KEEP

You've

GOING

got this

KEEP GOING... **YOU'VE GOT THIS**

Now that you've put yourself out there in the world — now that you've shipped — here comes the scary part. How will people respond? You'll get worried people will judge you. They will. You'll realize not everyone is going to agree with you. They won't.

Don't back down. It's worth it.

You'll stop yourself short on a project, imagining how people might not get it. And you know what? There will be plenty that don't. And that's ok.

Keep going, and trust you are doing incredible things.

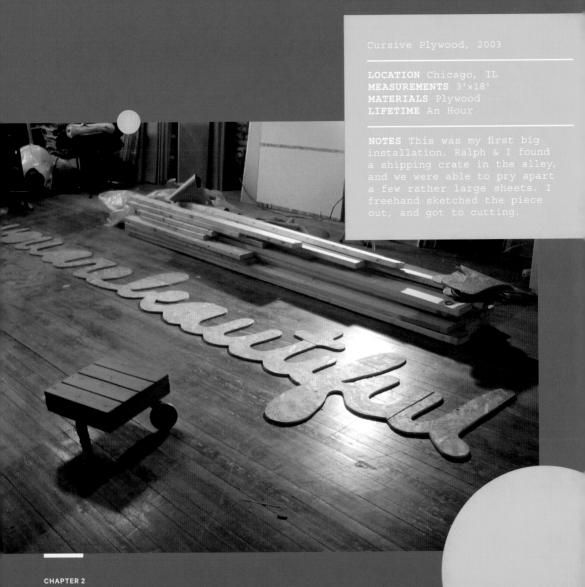

Cursive Plywood, 2003

LOCATION Chicago, IL
MEASUREMENTS 3'x18'
MATERIALS Plywood
LIFETIME An Hour

NOTES This was my first big installation. Ralph & I found a shipping crate in the alley, and we were able to pry apart a few rather large sheets. I freehand sketched the piece out, and got to cutting.

You have to be determined. You have to remember that being more than average, that doing extraordinary things takes a lot of emotional labor. And it might not always seem like it's worth it. But it is worth it. Every single time.

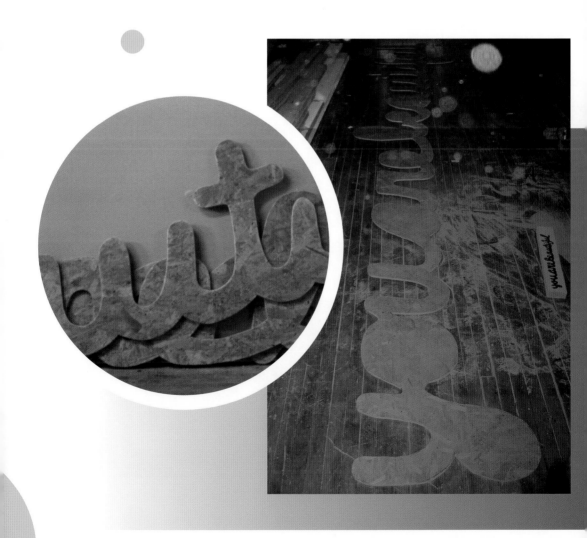

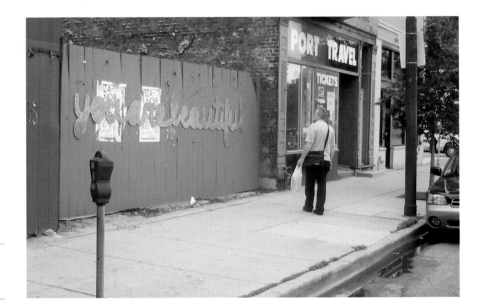

Go on, be a little rebellious.

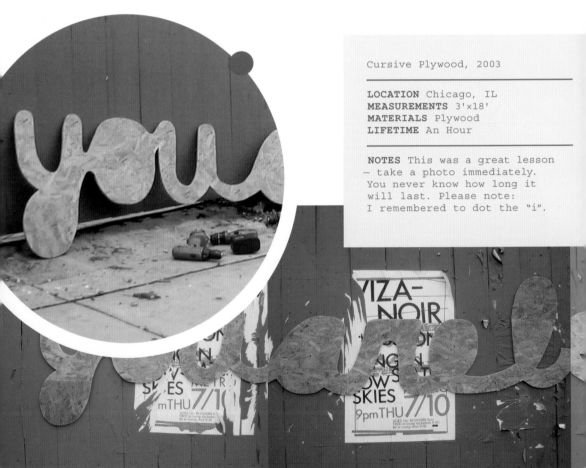

Cursive Plywood, 2003

LOCATION Chicago, IL
MEASUREMENTS 3'x18'
MATERIALS Plywood
LIFETIME An Hour

NOTES This was a great lesson
— take a photo immediately.
You never know how long it
will last. Please note:
I remembered to dot the "i".

I easily spent two weeks on this piece. I perfected it with three coats of varnish, and countersunk predrilled holes. I actually remember sanding the edges a few extra times, realizing that someone getting a splinter from touching the piece might change the message for them.

And then we felt the excitement and rush of putting something out into the world — feeling rebellious, and laughing about how people are going to encounter this, and how it's going to blow them away.

And then riding back there on my bike an hour later to find it gone.

Sometime later, I received an email from the person who took the piece. He wrote about how the message was just so powerful, the piece was so perfect, he was saving the piece from being destroyed. And whether or not his intentions were heartfelt and just a little misguided, he closed his email with, "It's on my living room wall, and I'm not planning to return it btw."

Just look at this guy. I snapped this photo as we were driving away. Even if it was just this one person — affected, given a moment. It was all worth it.

There is so much negativity in the world — be a force against it.

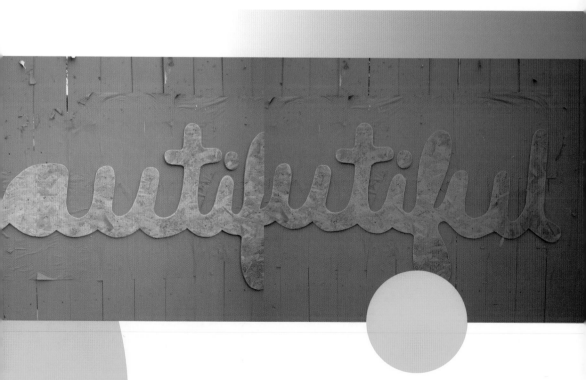

- Quite often, you'll be taken the wrong way and things will not always go according to plan. You'll find yourself in new places, amongst strangers, with the need to quickly understand each other. ~~Take it upon yourself to go above and beyond,~~ making sure you quickly see eye-to-eye.

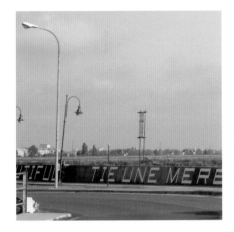

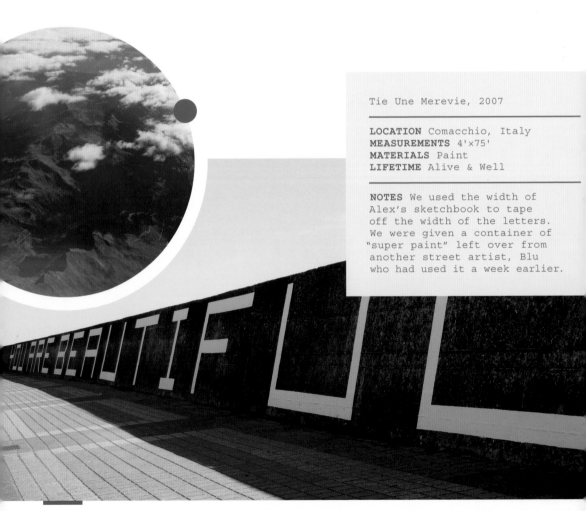

Tie Une Merevie, 2007

LOCATION Comacchio, Italy
MEASUREMENTS 4'x75'
MATERIALS Paint
LIFETIME Alive & Well

NOTES We used the width of Alex's sketchbook to tape off the width of the letters. We were given a container of "super paint" left over from another street artist, Blu who had used it a week earlier.

We had just been flown into a small town a few hours outside Venice, Italy, and began painting the retaining wall between the city and the ocean.

As we were about halfway through the phrase in the local Commachio dialect, we were stopped by no less than five groups of officers. We met the police, the military police, the chief of police, undercover police, and several groups of traffic police. We found out later they were kindly known as the "fashion police," with their white leather Armani gun holsters.

We did not speak Italian, and they spoke no English. We had to work very hard to explain why we were in the center of their town, painting on their historic ocean wall.

We had to be friendly and kind, and figure out a way to communicate without words. After we said the phrase "Tie una mere vie" (or "You Are Beautiful"), the conversation shifted. Handshakes, smiles, and laughter came about. The universal thumbs up were given.

The last group of police were able to communicate that the translation of the half-finished phrase was very close to "You Are Beautiful," as well as "You Are: [insert profanity here]." We quickly completed the phrase to avoid more confusion, and completed the trip without further complications.

It's not what you say, but how you say it.

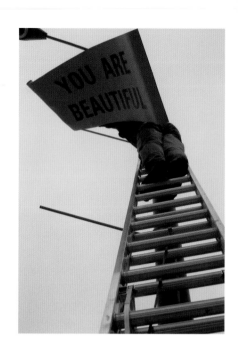

At some point, we all mess up. Failure is a part of life (and it shows we've actually done something). We strive to do things right, but sometimes our senses can turn out to be a bit misguided. Learn from failure, but don't let it slow you down. Better yet, embrace it. It's proof that you believed in something enough to risk it all.

White Type, 2005

LOCATION Chicago, IL
MEASUREMENTS 4'x12'
MATERIALS Contact Paper
LIFETIME Alive & Well

NOTES I brought a roll of hand-cut letters made from shelf lining paper, rented the longest ladder I could find, and battled the wind for the afternoon. It felt quite silly in the moment, but that piece is still there, standing strong many years later.

I once made a banner out of a piece of heavyweight fabric I found. I painted it white and used a stencil with red spray paint. I measured the distance on the outstretched poles, and asked my studio-mate (who made wedding dresses) if she would stitch the ends. My other studio partner had a grommet set, and we added those to the corners.

It was a joyful project — it only took a few days and cost me $3. I laughed at the idea: "Who makes a banner?" But I've found that, if a street installation looks legitimate and takes a ladder (or a large effort) to remove, no one seems up for the task. So I decided that I should "aim high."

We brought out a ladder on a particularly windy day. My measurements were a little too exact, leaving no play to finesse the banner on the poles. Since it was painted fabric, it ripped along the stitching line. We left it up for a few minutes. I stepped back, took a long look and said, "no, it needs to come down." Better luck next time.

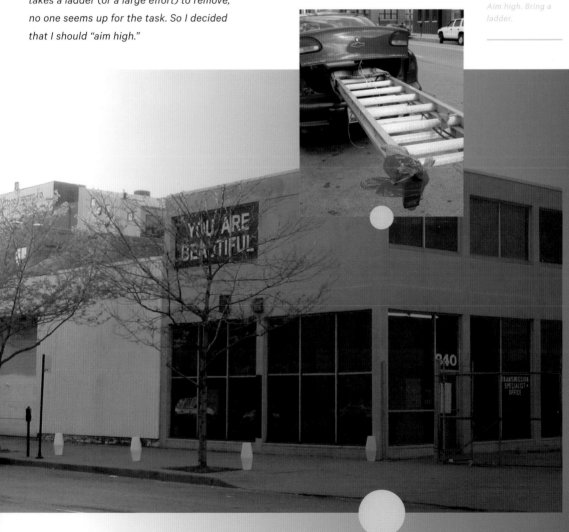

Aim high. Bring a ladder.

Get

Put your into

hands

back

it

your

dirty

●

If it were easy,
everyone would
be doing it.

If you're not going to give it your all, stop what you're doing and walk away. You need to be willing to do the heavy lifting, to do the millions of menial tasks that add up to success. Don't be above any job.

Sure, get help from others — we're in this together — but it's your responsibility to put your passions into the world.

Physical Lenticular, 2010

LOCATION Lisle, IL
MEASUREMENTS 11'×100'
MATERIALS Pine, Paint,
 Hardware
LIFETIME 6 Months

NOTES The face of this installation was created in a zigzag pattern, painted half-white and half-yellow. The piece was kinetic, and actually changed colors as you walked around it.

When you find things you're passionate about — ideas so exciting that you're willing to give it your all — find others who think like you, and work together. You need people to pat you on the back, look you in the eye and say, "We've got this." <u>Knowing people are there for you and that you're not alone is huge.</u>

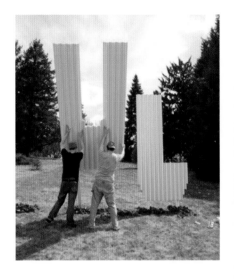

Every large-scale project I've ever done has been with a team of people. That's why I'm much more comfortable saying, "We did this" than "I did this."

To do things larger than life, I always know I need help — help to envision what we're doing, to plan it out and diagram it to a T. I need help to sketch it, to test it, to see what works and what doesn't. I need help to get the tools and the materials we need, to do all the small details no one ever notices,

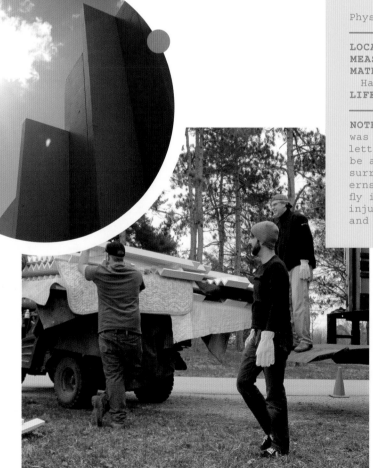

```
Physical Lenticular, 2010

LOCATION Lisle, IL
MEASUREMENTS 11'×100'
MATERIALS Pine, Paint,
  Hardware
LIFETIME 6 Months

NOTES The original concept
was to have large mirrored
letters. The viewer would
be able to see themselves
surrounded by nature. Conc-
erns arose that birds might
fly into the panels and get
injured. I changed concept
and design immediately.
```

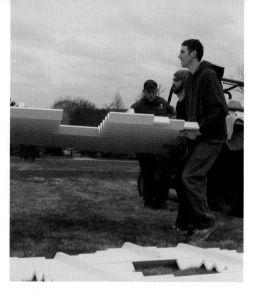

and help to construct the piece and build it. Then I need help to put it in a truck and ship it, to lay it out in a field and figure out the spacing, realizing that moving everything even just one foot to the right will take half an hour (and a lot of huffing and puffing). I need help to dig holes in the ground with big machines without hitting the water table below it. And finally, to put it up and stand back, seeing what we've been envisioning for months — for the first time in reality.

Do things larger than life.

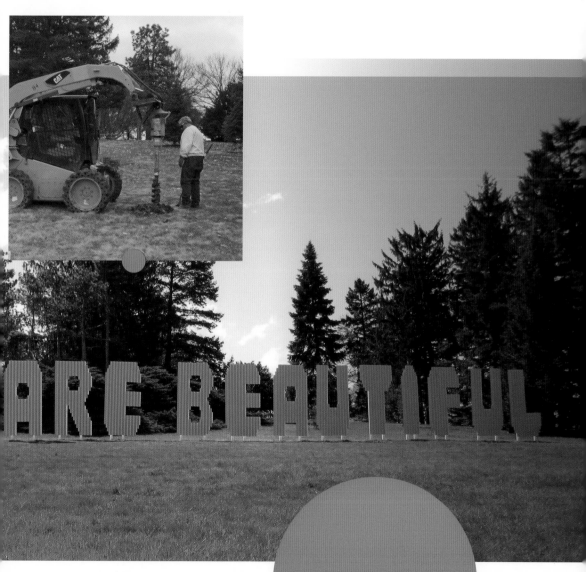

- **Doing the incredible involves a lot of mundane and non-glamorous effort. You are going to do a lot of thankless work. But it's not about the praise or credit, it's about doing what's necessary while trusting you're making a difference. All that time, all that effort, all the infrastructure to make it happen, just for that one incredible moment to feel human again.**

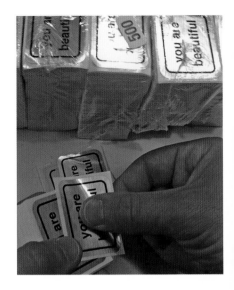

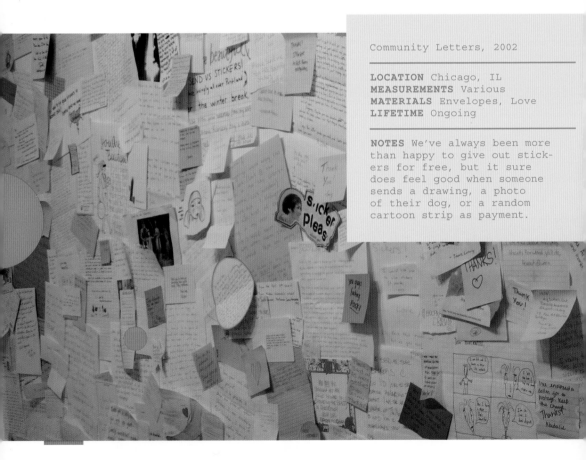

Community Letters, 2002

LOCATION Chicago, IL
MEASUREMENTS Various
MATERIALS Envelopes, Love
LIFETIME Ongoing

NOTES We've always been more than happy to give out stickers for free, but it sure does feel good when someone sends a drawing, a photo of their dog, or a random cartoon strip as payment.

I get out of bed every morning amped for what life is going to throw at me. I get to do some amazing things, like write this book, hand out oversized checks, be interviewed for Oprah, and create massive inspiring installations.

I also pack sticker orders, and answer emails and letters. I buy packaging materials and talk with vendors. I do all this because I know this starts with me. And if I'm not going to do it, if I'm not going to lead by example, then it's not going to happen.

To pull back the curtain a bit, it's wild to think that every one of the million stickers shipped over the last decade have gone through my hands. Do you know how tedious that is? A million stickers. But I continually remind myself "These are going out into the world. These are going to make a difference. I just know it."

It starts with you.

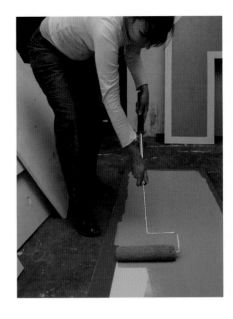

- <u>**Break through those moments when
you feel like giving up.**</u> **Go far beyond
your comfort zone, and push beyond
what you think is possible. Do it for
you. Do it to prove it to yourself. You'll
be surprised at the things you are
capable of accomplishing.**

Grey Letters, 2006

LOCATION Chicago, IL
MEASUREMENTS 8'x75'
MATERIALS Plywood, Paint
LIFETIME 1-Month

NOTES When Kim originally
pitched this idea to the
building owner, we shot for
the roof. After some safety
concerns, we landed safely on
the ground. It turned out to
be a more visible placement,
and became a temporary
landmark in the area.

We had been commissioned to put up an installation on a fence in the River North area of Chicago. The only catch was that there was no way to properly attach the piece, and we couldn't damage the fence. I designed a clamping system so the piece would sandwich around the fence. It was a great idea, but required some brute force to hold the letters in place as they were screwed together.

It was the biggest installation to date, and many friends came out to help. I created the "font" by cutting the least amount possible from solid 4'×8' sheets of plywood, minimizing the work. After we spent a few days painting the piece, it was all set for the install.

By the time "install day" arrived, the crew consisted of only myself and my friend Chris. We were struggling to put up the piece on a hot day when a homeless man saw that we needed help and jumped right in. He kept our spirits high with his lighthearted and inspirational words. He was so intrigued by what we were doing, by the message that we were trying to share. As we were putting up the last three or four letters, a flash thunderstorm came out of nowhere and we were dumped on— completely drenched. It was loud and crazy. I shouted "We're finishing!" over the storm and the man gave me a thumbs up and a head nod. We got it done.

You have nothing to lose, and everything to gain.

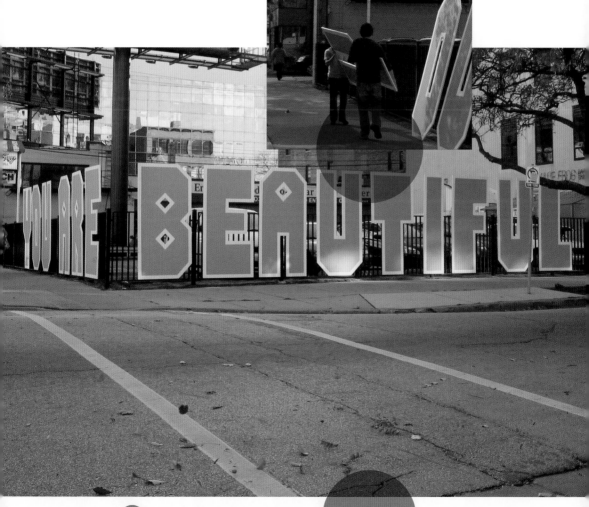

Take

action

●

*Get creative. Don't
allow excuses to
stop you from your
best work.*

At some point, you have to take
action. You have to brave the climb.
You have to make grand gestures,
and do unforgettable things. It's
at that moment when you need
to embrace risk, when there's no
turning back.

This is when you raise your hand,
hit send, say "I love you" and sit in
the silence before they respond. Do
things that scare the pants off you.

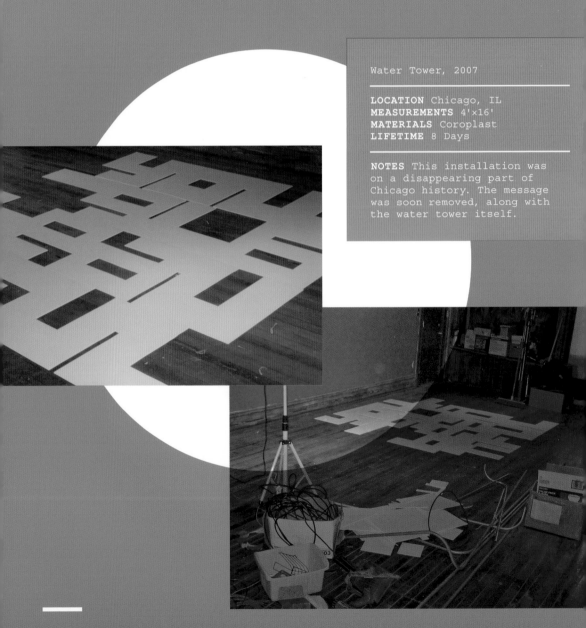

Water Tower, 2007

LOCATION Chicago, IL
MEASUREMENTS 4'x16'
MATERIALS Coroplast
LIFETIME 8 Days

NOTES This installation was
on a disappearing part of
Chicago history. The message
was soon removed, along with
the water tower itself.

It doesn't always have to be huge, or epic, or scary. It's so often the little things. Always be prepared. When an opportunity presents itself, make the most of it and give people something to smile about.

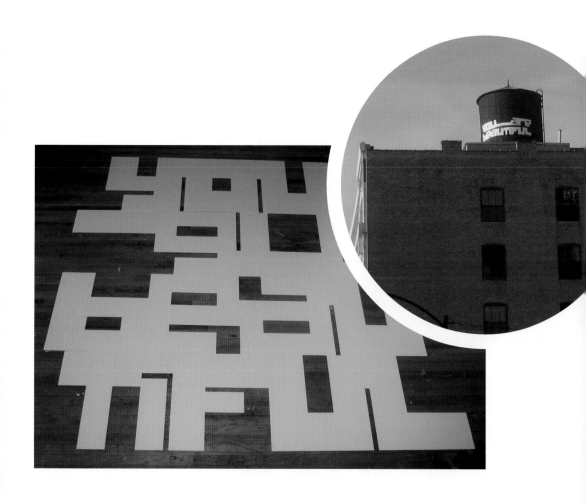

I was running late for work on a Monday morning, stuck in traffic on the Touhy exit ramp off the Edens Expressway in Chicago. Having just watched the light change from green to yellow to red three times without moving an inch, I sat there and just stared at this pole. I remembered I had some letters from a hardware store stashed away in my glove box for a rainy day. Before I knew it, I was standing outside my parked car, driver's door swung wide open, putting these letters on this pole.

It took me a few minutes to put it up, and there were two empty car lengths in front of me as I finished. No one honked, they just watched — with confusion at first, followed by big smiles. I got back in my car and eventually got off the exit ramp. The piece ended up lasting for years, a daily reminder to me and everyone else who took that exit on their commute.

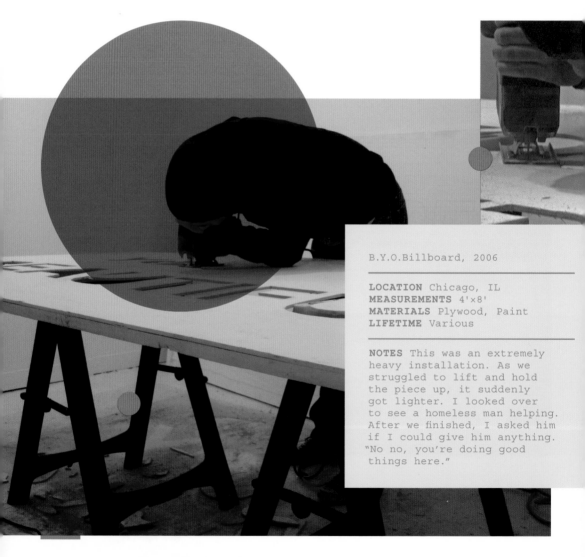

B.Y.O.Billboard, 2006

LOCATION Chicago, IL
MEASUREMENTS 4'x8'
MATERIALS Plywood, Paint
LIFETIME Various

NOTES This was an extremely heavy installation. As we struggled to lift and hold the piece up, it suddenly got lighter. I looked over to see a homeless man helping. After we finished, I asked him if I could give him anything. "No no, you're doing good things here."

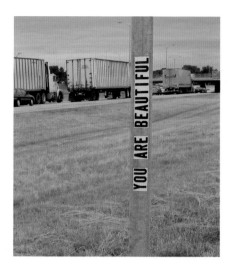

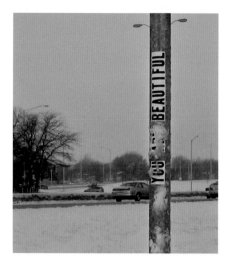

Little things add up to make a huge difference.

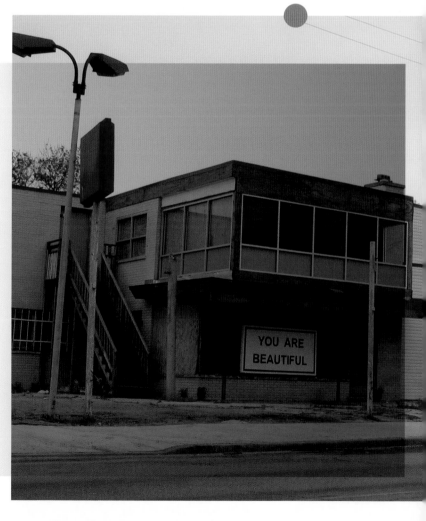

- **You have to get creative and invent new ways of doing things. No one is going to do it for you. It's up to you to find your own way, make your own decisions, and often create your own realities. Don't get discouraged by this. In fact, make it fun and be up for the challenge.**

Green Posters, 2003

LOCATION Chicago, IL
MEASUREMENTS 13"x13.5"
MATERIALS Heavy-Weight
 Gloss Posters
LIFETIME Various

NOTES Often when we put these posters up, we'd staple them to an abandoned storefront with a sign that read "Take one and spread your beauty." People snagged these posters faster than anything I've ever seen.

Starting out, I didn't really have any money to put towards making these grand ideas become reality. Instead of buying a new pair of sneakers, I would buy stickers or supplies to make a new installation.

As the projects got bigger, I was able to get funding for materials. All the labor was still free, and I depended on friends to help out on evenings and weekends.

At one point I received a grant to get three thousand posters printed. Paying for advertising space was out of the question, so we had to find creative spots to put them.

The posters were sized perfectly to be lightly placed into empty advertising spaces on the trains. One evening, armed with 40 pounds of posters, an off-duty security officer stopped us. He said, "Are you putting these posters up? Give me one — my wife is going to love it!" At that moment, I realized we were creating positive interactions that kept giving back.

Be your own client, and do your best work.

- Speak up. Your voice matters. Shout it from the rooftops, whisper it in our ear, and say it to our face. Do whatever it takes to get your passions out there. We want to hear what you have to say — we want to know what has you so worked up. Take a deep breath, and risk it all.

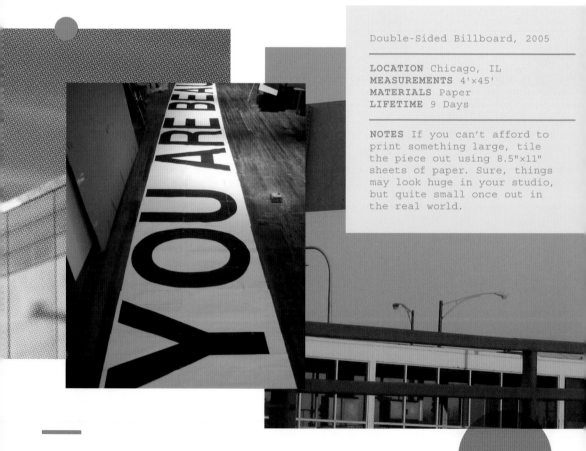

Double-Sided Billboard, 2005

LOCATION Chicago, IL
MEASUREMENTS 4'x45'
MATERIALS Paper
LIFETIME 9 Days

NOTES If you can't afford to print something large, tile the piece out using 8.5"x11" sheets of paper. Sure, things may look huge in your studio, but quite small once out in the real world.

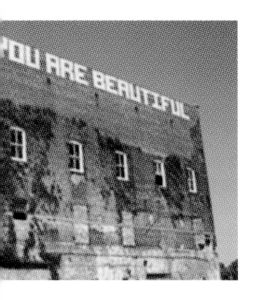

This piece has been widely photographed, and appeared in the opening sequence of Banksy's Exit Through The Gift Shop. The building was abandoned when the piece went up, but it has since been remodeled into high end lofts. The message has been so warmly embraced that it's now a selling feature for the building.

ANONYMOUS: *"I planned it out, I counted how many bricks it was across and drew it out on a piece of graph paper, making sure each letter would fit just right. It took all night to paint."*

"My painting was in the introduction. It blew me away. I told my friend, 'I PAINTED THAT!' He was like, 'What do you mean, YOU painted that?'

We want to know what has you so worked up.

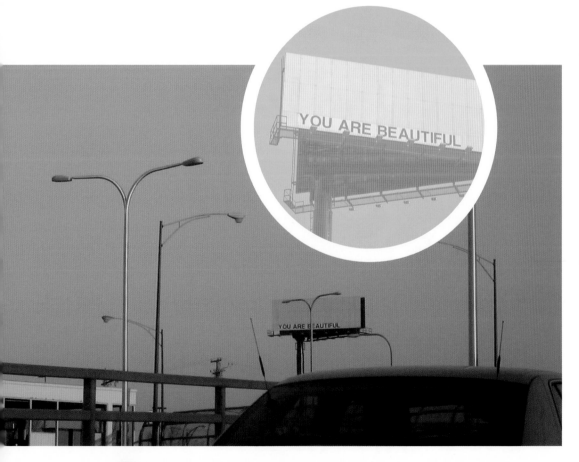

CHAPTER 5

Create an

Do a lot

with a

little

CREATE AN IMPACT... **DO A LOT WITH A LITTLE**

One powerful message, three simple words. A small tiny sticker, stuck over one million times, on any available surface, on every continent of the world. Grabbing strangers unexpectedly in the grind of their daily life and unapologetically saying it's OK to be human. From bathroom stalls to locker rooms, street signs to lampposts, given with a tip for dinner, or left on a bus seat or in the back of a cab. This isn't a fad, this isn't going away. This is a global movement of people being human around the world. They're being audacious, they're being a little dangerous, they're giving gifts, and having fun.

Take each moment one at a time.

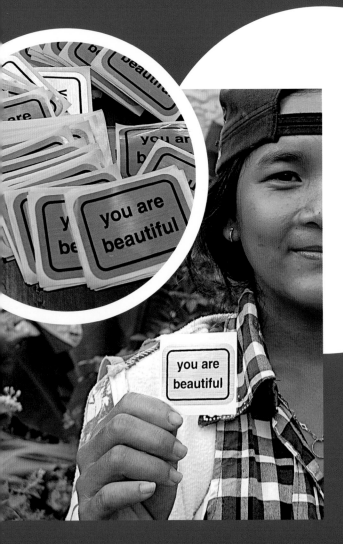

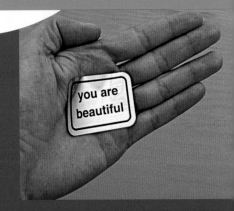

Silver Sticker, Since 2005

LOCATION Global
MEASUREMENTS 1.5"×2"
MATERIALS Silver-Foil
 Sticker
LIFETIME Various

NOTES We have printed and distributed over one million stickers since 2002. It took ten years to print the first 500,000. The second half million were printed in less than a year.

Leave your mark. Experience all the world has to offer, and take yourself with you wherever you go. <u>Your kindness is worth a lot.</u> It's something you can give away and use to help create moments that others would never trade.

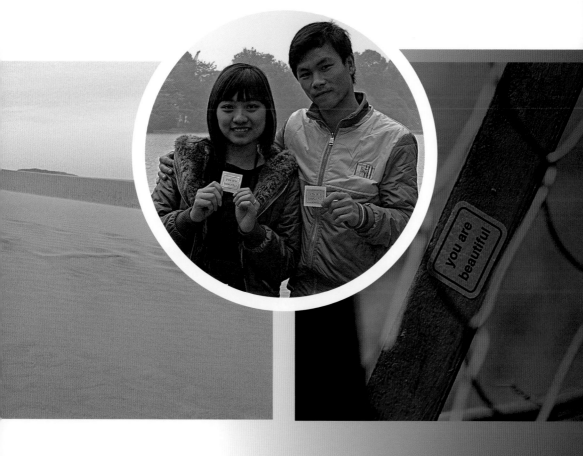

The community uses these stickers as travel companions, marking where they've been. Entire travel albums are filled with photos from city to city, and there isn't a page without at least one sticker snuck inside. Travelers have often used stickers as an alternative to currency, trading this positive message for a couch to sleep on or a meal to eat.

JEAN-ÉTIENNE PARROT: "*I only had stickers with me for a few months before I started preparing for my trip around the world.*

One day a good friend suggested I should have a little project instead of just taking traveling photos. The stickers became the perfect subject for a series with the world's landmarks. I would take pictures featuring a sticker, and also give out as many as I could along the way. I placed stickers in Amsterdam, St. Petersburg, Indonesia, at The Great Wall of China and the Temples of Angkor, and I gave many more to people I met. I gave them to fellow travelers, hosts or friends, but most of the time to kind people, those who dared to smile or simply start a conversation with a complete stranger. To all of those people, and many more, I gave stickers and told them they are beautiful."

Silver Sticker, Since 2005

LOCATION Global
MEASUREMENTS 1.5"×2"
MATERIALS Silver-Foil
 Sticker
LIFETIME Various

NOTES The *You Are Beautiful* sticker has been translated into over 30 languages, we've created close to 40 different designs. The silver sticker became the well-known classic.

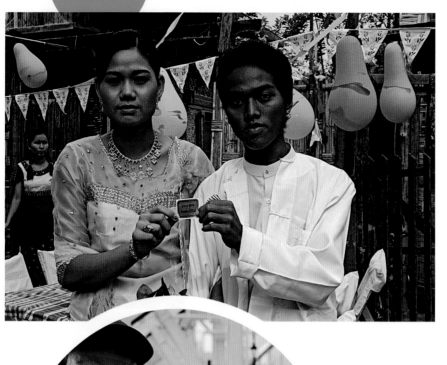

Share your journey.

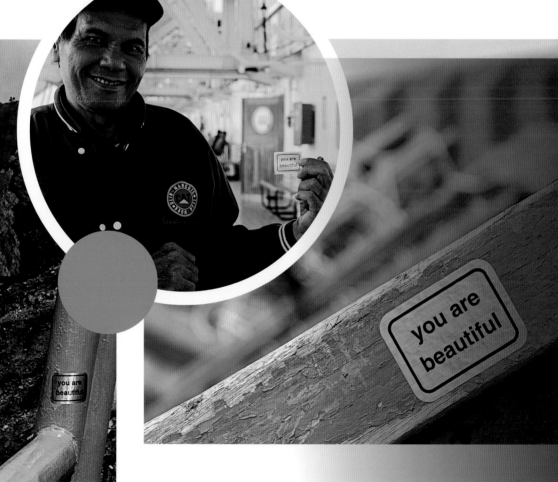

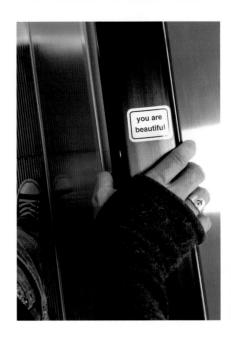

- **You can make a difference on a per-sonal level right in your own neigh-borhood. <u>You don't have to go far to change the world, to change your world.</u> Do something positive, and see if you hear any murmurs, whispers, or laughter. Do it each and every day.**

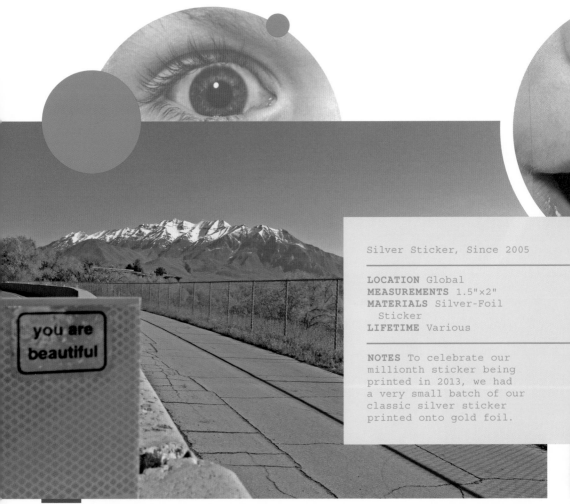

Silver Sticker, Since 2005

LOCATION Global
MEASUREMENTS 1.5"×2"
MATERIALS Silver-Foil
 Sticker
LIFETIME Various

NOTES To celebrate our millionth sticker being printed in 2013, we had a very small batch of our classic silver sticker printed onto gold foil.

NATE: "I fell so hard in love with this project when I found it. The larger message genuinely resonates with me. I want to be someone who helps others feel the true heft of their worth. Now I leave stickers wherever I go. As I post each one I visualize someone coming across it and feeling like it was put there specifically for them to find. I do it because people need to know the truth. And they need to know others know it too."

Personally, you couldn't pay me to take a relaxing walk. But almost every weekend, I'll walk for hours, slapping up hundreds of stickers. It makes me feel like I've accomplished something. I know that for every hundred, only one might last — but that one sticker could make all the difference in the world.

Find your way to
make a difference.

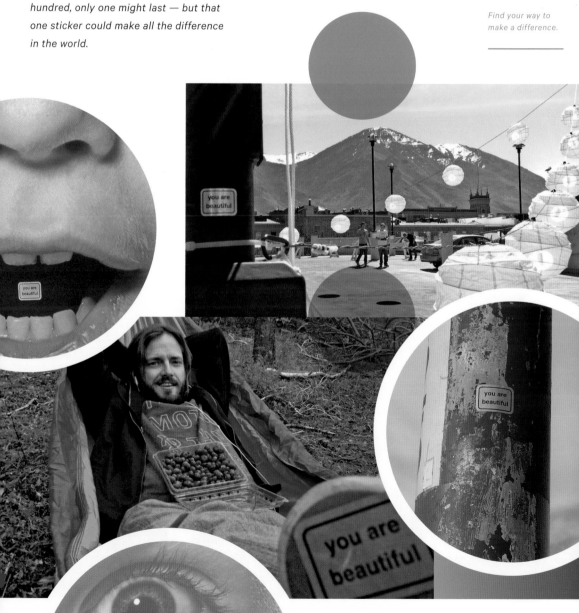

• **You don't have to change the entire world to change someone's world.** <u>A small thing you do could mean more to someone than you will ever know.</u> **Subtle as they may be, those little things are contagious and can deeply impact someone in a positive way forever.**

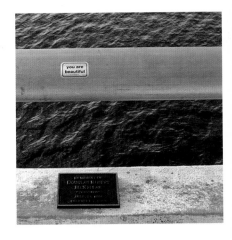

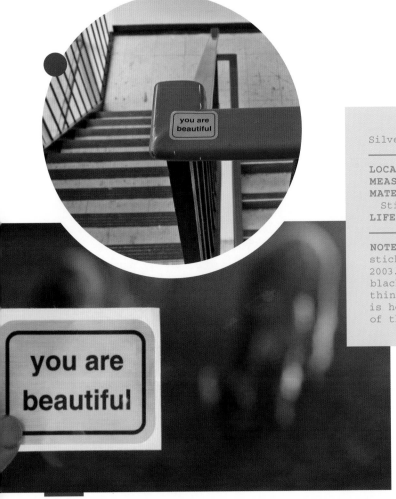

Silver Sticker, Since 2005

LOCATION Global
MEASUREMENTS 1.5"×2"
MATERIALS Silver-Foil
 Sticker
LIFETIME Various

NOTES The now-classic silver sticker was first released in 2003. In the early years, the black border was considerably thinner than it is now. This is how you can tell the age of the sticker.

While the spread of this idea is impressive, it only takes one to truly make a difference. This sticker was placed on a bridge guardrail in Melbourne, Florida, where someone's friend had committed suicide. The young woman that sent in this photo with her letter, said that she hoped that the next person reaching that point, would rethink their actions, remembering their beauty and their self worth. It reminds us that this silver sticker might not change the world, but it will change someone's world.

SHANNON LOUCKS: "I was at the deli counter getting some cold cuts. The woman behind the counter was full of kindness and joy. She lifted my day. So as she handed me my meat, I handed her a sticker. She looked down at it smiling at me wide and full. And then she turned and danced toward her coworkers shouting, 'Oh look what I got! And it's so true.' I am not sure which one of us was more uplifted that day."

SHANNON LOUCKS: "I was at a thrift store. After finding our treasures, I stood at the till. A male worker called to a woman to help me. She arrived lost of her enthusiasm. A scarf was all that covered her head. She shared as few words as she could. When our money exchange was complete, I handed her a sticker. That is when I saw her heart, right there in the smile that brought a tear to both of our lives."

NICOLE EVERSGERD: "I was at Schubas watching someone perform and went to talk with him after his set. He was a bit down as someone close to him had just passed away. I handed him a You Are Beautiful sticker and his face lit up. He said he was locking his bike up years previously in NYC on a particularly bad day and seeing one of these stickers changed his day. Now getting a sticker in Chicago years later once again helped to cheer him up. I could see he was genuinely moved."

This will change someone's world.

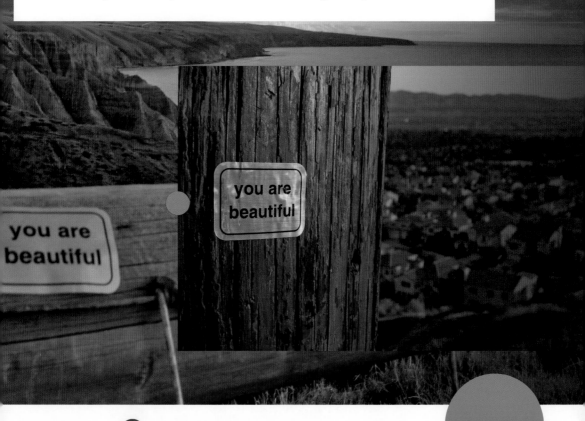

START

a

con
vers
ation

See where it leads

START A CONVERSATION... **SEE WHERE IT LEADS**

"Hey, this is what I'm about."

Nothing happens when you keep your ideas inside. On the other hand, all sorts of wild and unexpected things can happen when you share yourself with the world.

Your individual voice starts to change and evolve. It turns into a conversation, and nothing is ever the same. Just say hello. Say something. Take it slow and see where it leads. See how other people engage in what you have to say. People will surprise you. Let them.

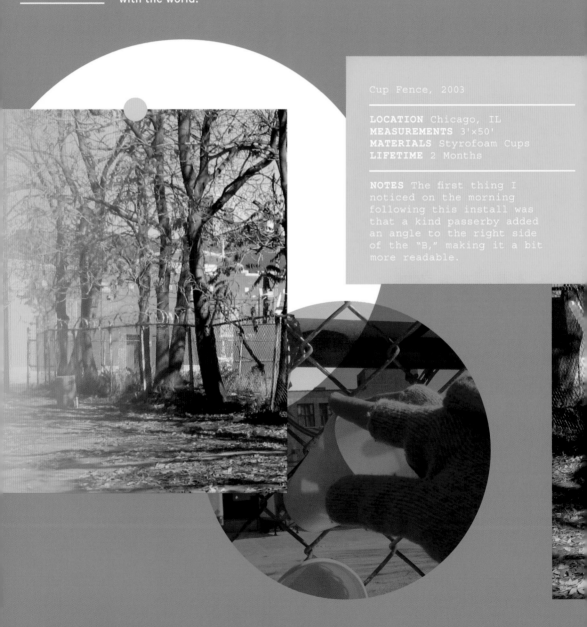

Cup Fence, 2003

LOCATION Chicago, IL
MEASUREMENTS 3'×50'
MATERIALS Styrofoam Cups
LIFETIME 2 Months

NOTES The first thing I noticed on the morning following this install was that a kind passerby added an angle to the right side of the "B," making it a bit more readable.

Sometimes we're just waiting. We're waiting for you to make the first move. And once you put it out there, then we can react and join in. We want to hear what you have to say, and we want to add our voice to the conversation. Say interesting things, step back and watch what unfolds.

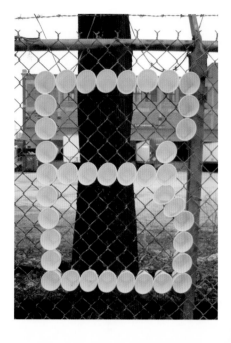

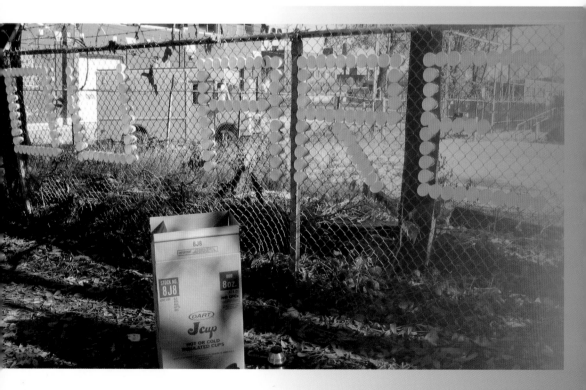

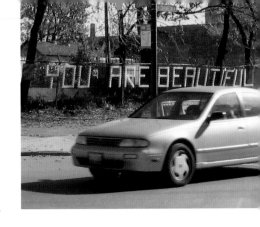

Early one Sunday morning, when I put these styrofoam cups in a fence along Damen Ave. in the warehouse district of Chicago, I had no clue I'd be sparking a two-month-long conversation with the neighborhood. This fence went from positive to negative with every volley, changing over 15 times. To this day I have no idea who was doing it.

Individual voices change into a dialogue.

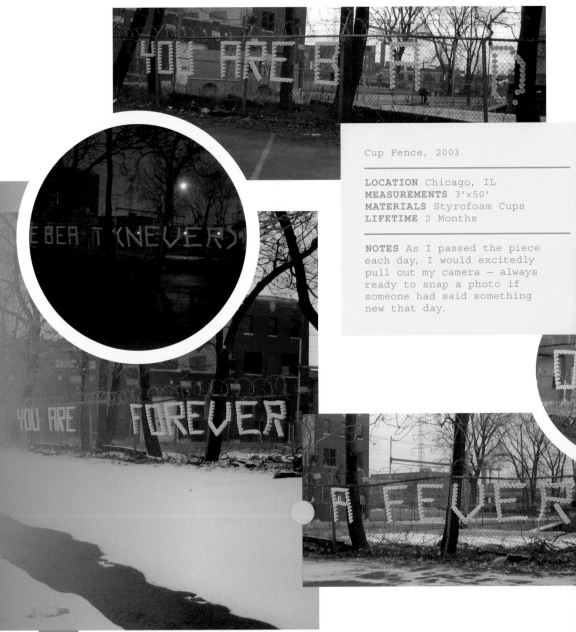

Cup Fence, 2003

LOCATION Chicago, IL
MEASUREMENTS 3'×50'
MATERIALS Styrofoam Cups
LIFETIME 2 Months

NOTES As I passed the piece each day, I would excitedly pull out my camera — always ready to snap a photo if someone had said something new that day.

The phrase quickly changed to different messages. You are bad. You are beat. Never. You are forever. A fever. A lover. And over. (But it wasn't.) Because you are loved. Disappointed. And rejuvenated. And as suddenly as the conversation began, our little dialogue on the fence disappeared.

You never know what will happen when you put yourself out there.

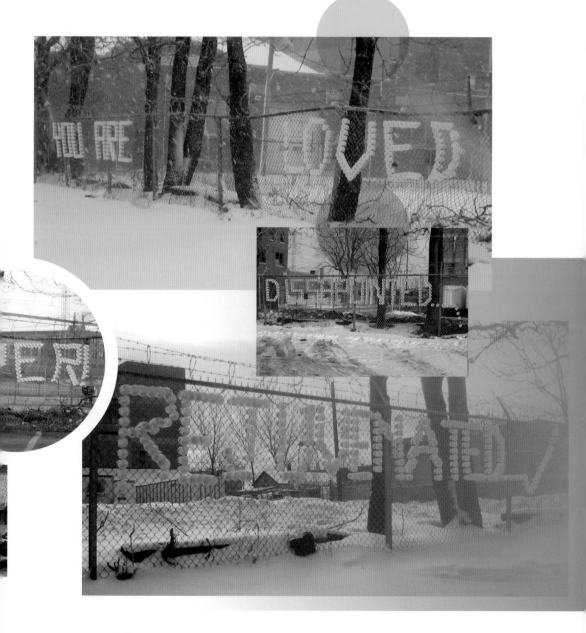

- Have the will to make things better, and help will show up. People are eager to show off what they can do. Invite others to rally around you. Banding together in the moment creates a lasting impact.

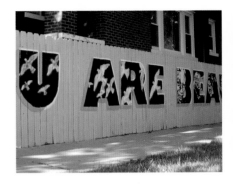

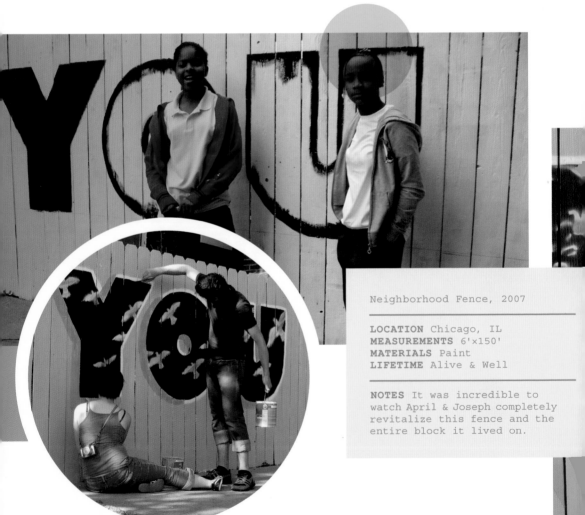

Neighborhood Fence, 2007

LOCATION Chicago, IL
MEASUREMENTS 6'x150'
MATERIALS Paint
LIFETIME Alive & Well

NOTES It was incredible to watch April & Joseph completely revitalize this fence and the entire block it lived on.

This mural was made entirely by volunteers using scavenged or found materials. April worked at an after school program with students on the South Side of Chicago. Their classroom looked across the street to a dilapidated fence, and they decided to make a difference.

The fence was part of an ongoing cycle. It would be tagged, power-washed by the city, and the process was repeated —leaving the fence with significant wear and tear. After receiving permission from the family who owned the house, they set out to paint the mural.

Joseph took photos of the students and created stencils to make up the letters. The mural was painted over a weekend, and the students were completely surprised to see their faces across the street from their school on Monday. The family loved it, the community adored it, the kids were blown away, and it made a difference on that block.

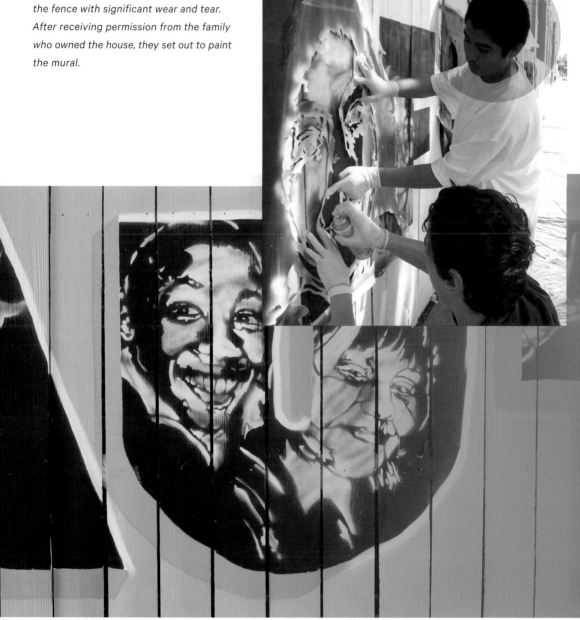

- **You have no idea if the things you say will last for seconds, or forever. You never know what will happen with what you put into the world — and that's the exciting part.** You have to keep creating, keep shipping, and trusting incredible things will happen.

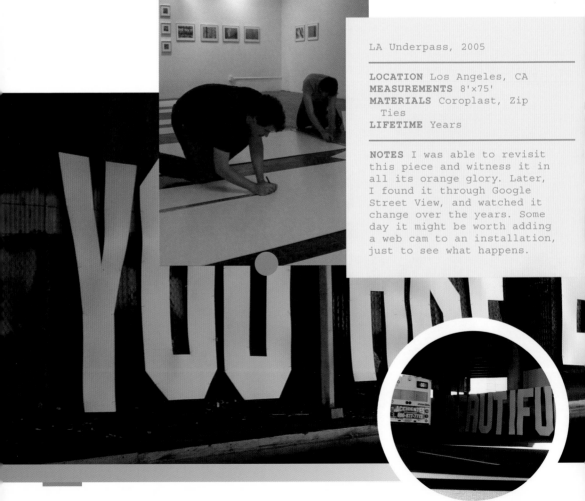

LA Underpass, 2005

LOCATION Los Angeles, CA
MEASUREMENTS 8'x75'
MATERIALS Coroplast, Zip
 Ties
LIFETIME Years

NOTES I was able to revisit this piece and witness it in all its orange glory. Later, I found it through Google Street View, and watched it change over the years. Some day it might be worth adding a web cam to an installation, just to see what happens.

We tied this piece to a fence in Los Angeles, California, literally on our way to the airport. Our bags were packed, but there was just one more thing I wanted to do. We threw these letters on top of the rental car, and stopped at the first fence we found. We tied it up, zipped to the airport, and barely made our flight. The bright white letters glistened under the dirty underpass. I was curious to see how long it would last.

It was immediately covered in tags, which made it look pretty cool. Then the city came along and painted over it (but didn't remove it). Months later, someone painted it fluorescent orange. At one point it was damaged, and someone fixed it.

Over the years, I've come across photos of it online and in print. Couples have used it for their engagement photos and a band once used it on their album cover. I even came across a photo of Katy Perry pictured in front of the piece in a magazine that I was flipping through at a bookstore.

Eventually, it was completely remixed, and I'm not even sure they are the same letters. Years later, this underpass is still talking, still having a conversation.

Do everything you can. Then a little more.

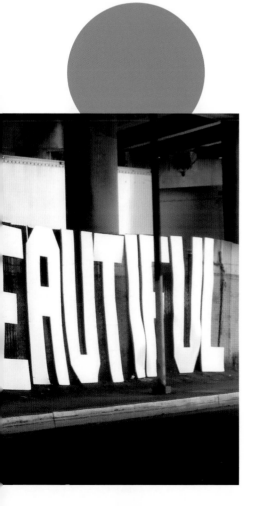

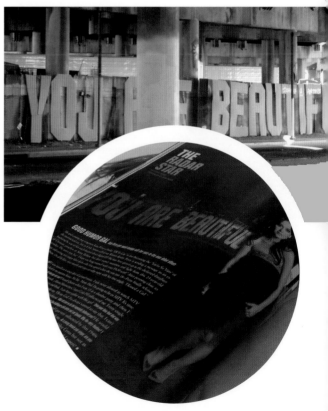

Make it
yours

5

with it

●
——————————

Let's be human to each other.

——————————

This message is spreading like wild fire. These are people, busy people, taking time out of their lives. People giving gifts to other people. Being human. Individuals from diverse backgrounds, ages, nationalities, life experiences, and geography are creating unique and memorable moments... For you.

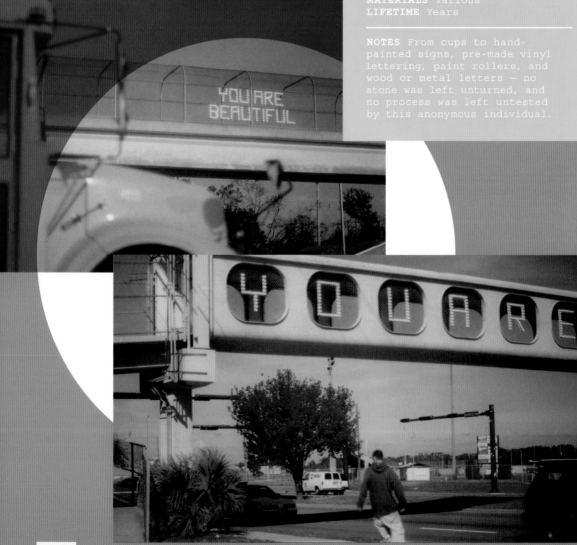

Hurricane Ivan Pieces, 2004

LOCATION Pensacola, FL
MEASUREMENTS Various
MATERIALS Various
LIFETIME Years

NOTES From cups to hand-painted signs, pre-made vinyl lettering, paint rollers, and wood or metal letters — no stone was left unturned, and no process was left untested by this anonymous individual.

Life is a process. A journey, and we are always building and rebuilding. You are resilient and built to handle what this life has to throw at you. **Often, when things are at their lowest, we learn the most and can achieve some pretty remarkable things.**

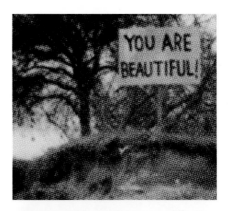

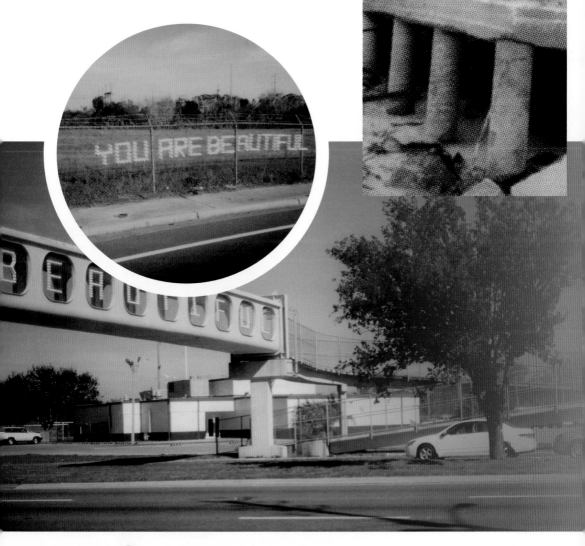

Sometimes, one piece becomes an entire campaign. After Hurricane Ivan in 2006, the city of Pensacola, Florida was left in shambles. As the rebuilding began, these positive messages started popping up everywhere. Over those few months the city was overhauled. The entire landscape of the city changed that year, and this message was part of the healing process. It made all the local papers, and a two-minute segment on the evening news.

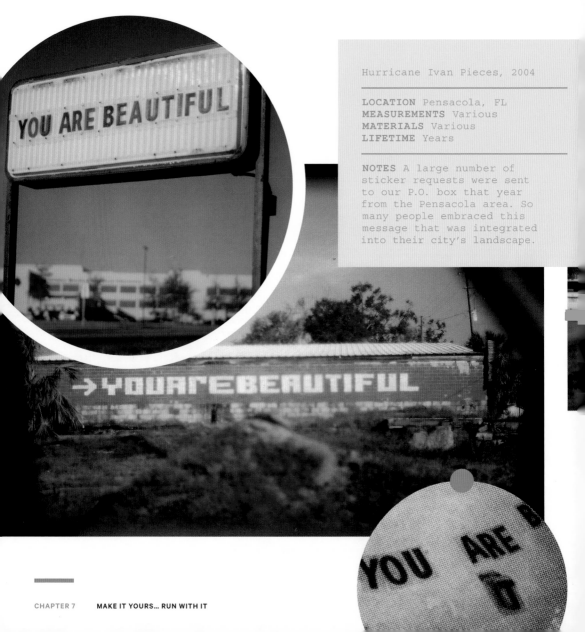

Hurricane Ivan Pieces, 2004

LOCATION Pensacola, FL
MEASUREMENTS Various
MATERIALS Various
LIFETIME Years

NOTES A large number of sticker requests were sent to our P.O. box that year from the Pensacola area. So many people embraced this message that was integrated into their city's landscape.

REPORTER: *Pensacola, Florida has been covered in graffiti, but some are saying it's not so bad, it's not so even that unsightly as News Central's Dan Thomas explains. It's art with a positive message.*

DAN THOMAS: *You may have looked up and seen it on an overpass while stuck in traffic. Maybe you noticed it through the corner of your eye as you merged onto the interstate, or it may have been painted in bold letters in the side of a building. You are beautiful is flattering people all over town.*

BETH GAGNON: *I got a kick out of it, it's a positive message at least. It's not some bad words or something like that.*

JOE STELLFI: *I thought that was great. I think there needs to be more of it in the area. And... I was curious who did it!*

GUY 1: *Somebody's got nothing else better to do. Waste the time.*

GUY 2: *I don't know why they are doing it, it doesn't make sense.*

ERIC JONES: *I wanna go back and inscribe — no I am not beautiful. I got acne, a parking ticket — I am not beautiful.*

JOE STELLFI: *Everybody's beautiful. It's all what's inside of ya. Right? Having a positive attitude, can make all the difference in the world.*

Spread a positive message.

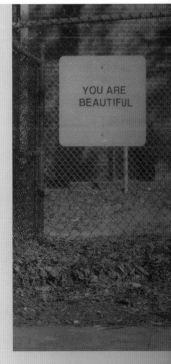

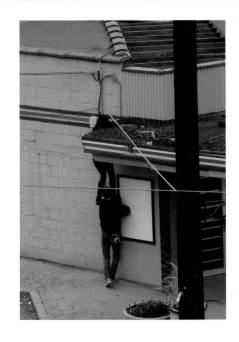

- **Get involved for the long haul. Make things that last the test of time and that people will enjoy and cherish.** ~~Create something positive and watch how it shapes your community.~~ **Listen to the good vibrations of what one action can do.**

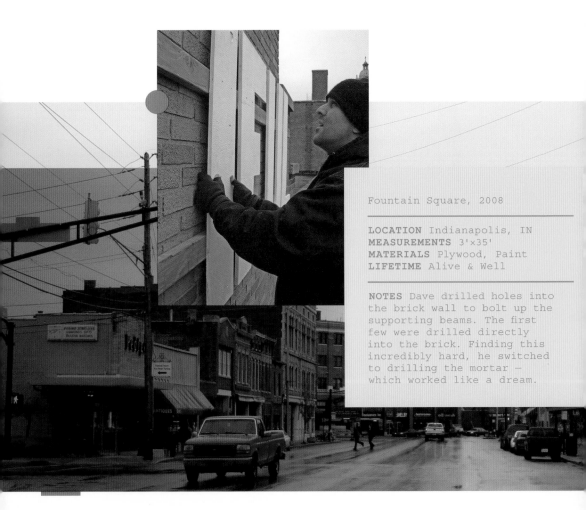

Fountain Square, 2008

LOCATION Indianapolis, IN
MEASUREMENTS 3'x35'
MATERIALS Plywood, Paint
LIFETIME Alive & Well

NOTES Dave drilled holes into the brick wall to bolt up the supporting beams. The first few were drilled directly into the brick. Finding this incredibly hard, he switched to drilling the mortar — which worked like a dream.

There are those who slap up a sticker or two, those who may share the message with others for a season in their world, those who create inspiring installations and head-turning murals. And then there are people like Dave and Holly.

This couple lives and breathes the You Are Beautiful *message*. They've put up numerous massive installations. Arguably, this piece is the most noteworthy (and shared most regularly via social media). It was originally intended to be temporary, but now is the entrance piece on a landmark building in the historic Fountain Square neighborhood of Indianapolis, Indiana.

DAVE & HOLLY COMBS: We needed to hear that message just as much as we needed to share it. We didn't know it at the time, but the simple idea of filling that blank space with meaning was going to change our lives.

When we think about the countless number of people who have seen the installation and how it has impacted their lives, we're so grateful to have been able to do it. We would say to anyone that you'll never regret any amount of time or resources you put into helping spread this message.

Make lasting change.

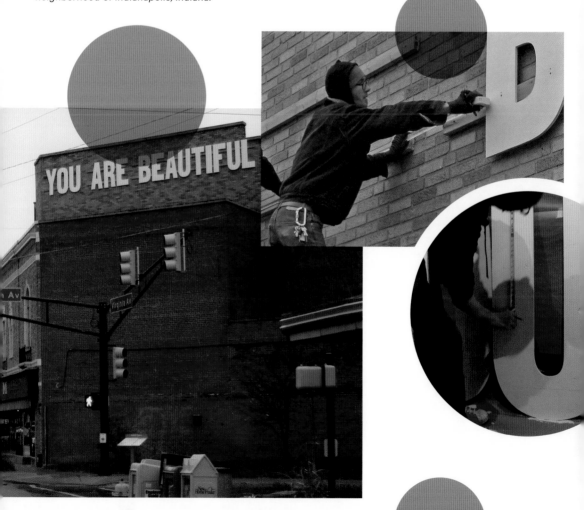

Life is open source — it's for everyone to interpret, rework, and experience the way they want to. You may not feel like you have the time, the skill set, or the opportunity. But everyone has something to offer, and we all can contribute in our own ways. Get inventive and work things into your life.

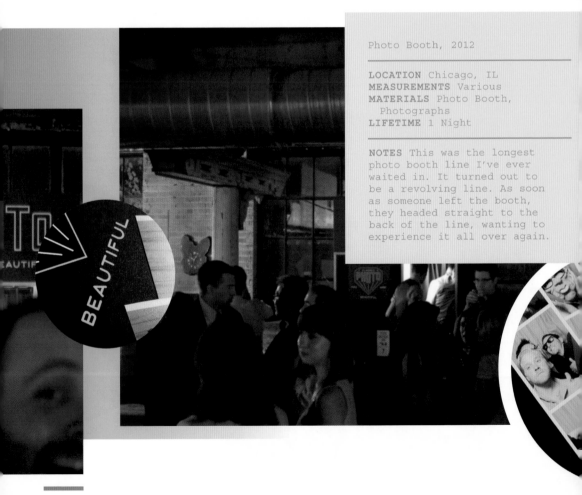

Photo Booth, 2012

LOCATION Chicago, IL
MEASUREMENTS Various
MATERIALS Photo Booth,
 Photographs
LIFETIME 1 Night

NOTES This was the longest photo booth line I've ever waited in. It turned out to be a revolving line. As soon as someone left the booth, they headed straight to the back of the line, wanting to experience it all over again.

This message has always been participatory, up for grabs, and open for others to take and run with. Nick created a You Are Beautiful *photo booth and it was a spectacle, a moment everyone enjoyed sharing. It got people to smile, have fun, and see themselves in a positive light. Nick set the stage, and the participants did all the rest. Every single person walked home with photos from the night, a positive message, and an incredible memory.*

Bring your strengths to the table.

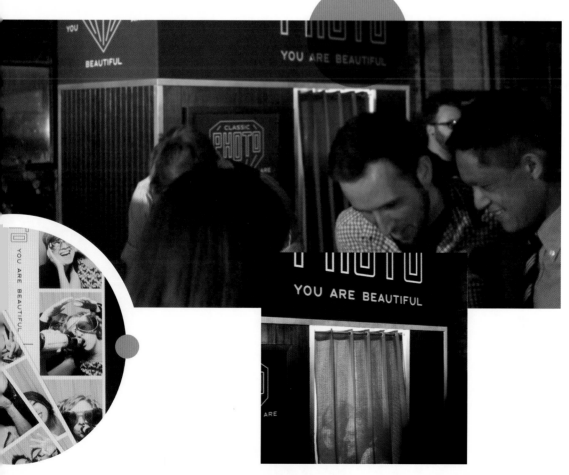

WORK T

Invite people int

R

world

your

TOGETHER

pt.1 DO MORE
WITH OTHERS

pt.2 YOU ARE
I AM

pt.3 FIND POSITIVE OUTLET
INSPIRE EACH OTHER

WORK TOGETHER... INVITE PEOPLE INTO YOUR WORLD

Make a plan to get together.

More happens when we work together. We end up finding ourselves able to do things we could have never dreamed of when we were going at it alone.

Give someone a chance to shine, give others the opportunities you've only dreamed of, and watch them do incredible things. Lend a hand, collaborate, and remember that we're all in this together.

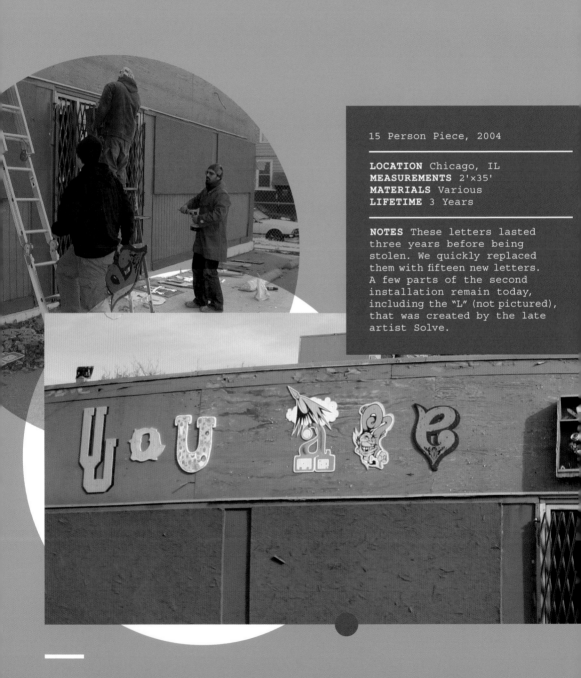

15 Person Piece, 2004

LOCATION Chicago, IL
MEASUREMENTS 2'×35'
MATERIALS Various
LIFETIME 3 Years

NOTES These letters lasted three years before being stolen. We quickly replaced them with fifteen new letters. A few parts of the second installation remain today, including the "L" (not pictured), that was created by the late artist Solve.

Work side by side, and inspire each other. Watch closely and pay attention — there's something to be learned from every person and each interaction. Absorb the good from others, and share yours right back.

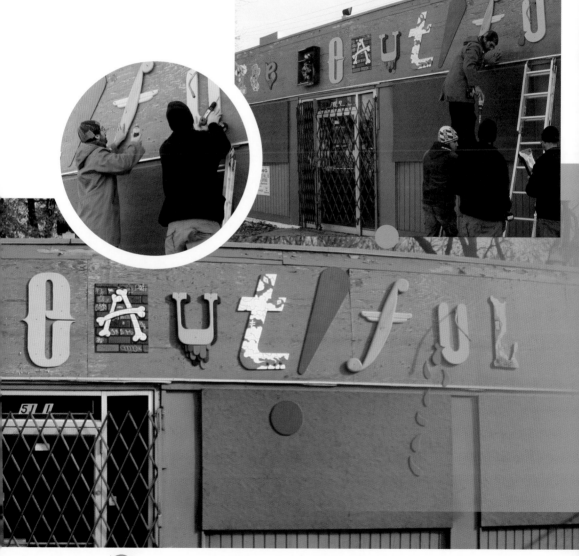

Thousands of artists from around the globe have worked on this project in many different ways. From big name creatives to young kids creating their first expression ever, all have had their own unique input. The many distinct voices of the community are loud and apparent.

It's hard to ignore the fact that none of this would have been possible individually. And while each person (or group of people) created these works on their own, it was speaking to a greater message, one that unifies the work to a higher level.

BUFF MONSTER: "It's super powerful, and empowering in it's understated simplicity. I was happy to be involved in this great campaign."

DREW BLOOD: "Just the spectacle of it all drew a large crowd. People wanted to know what was going on, and then stayed to party when they got the 'message' of the show."

MARURIZZIO HECTOR PINEDA: "We had received over 150 You Are Beautiful pieces. The opening night was interesting because there were no specific artists being celebrated. It was simply an overall statement of beauty and community."

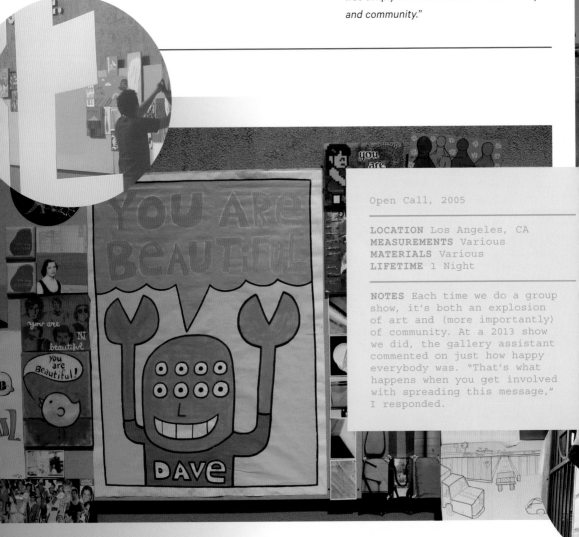

Open Call, 2005

LOCATION Los Angeles, CA
MEASUREMENTS Various
MATERIALS Various
LIFETIME 1 Night

NOTES Each time we do a group show, it's both an explosion of art and (more importantly) of community. At a 2013 show we did, the gallery assistant commented on just how happy everybody was. "That's what happens when you get involved with spreading this message," I responded.

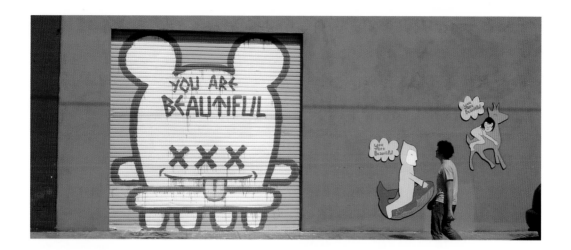

We're all in
this together.

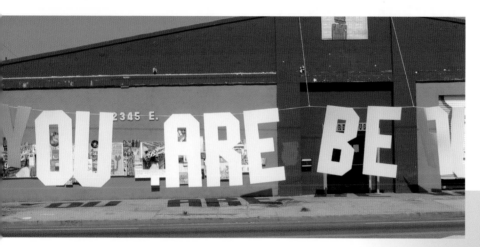

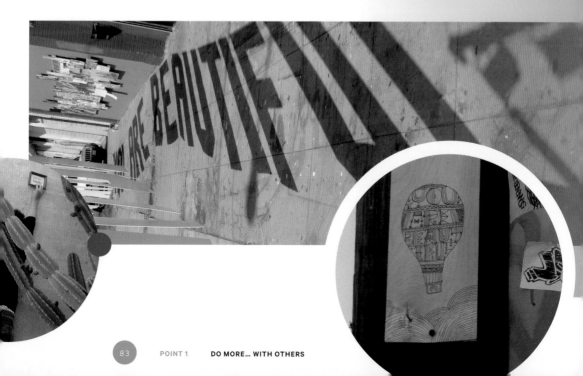

What we say and what we do in this world is a reflection of ourselves. It's wise to treat <u>everyone as you would want to be treated.</u> It might not always happen in return, but that doesn't change a thing. This is quite possibly the hardest lesson for many of us: respect yourself in the same way you respect others — remember what makes you great.

You Are I Am Books, 2004

LOCATION Chicago, IL
MEASUREMENTS Various
MATERIALS Various
LIFETIME Days - Week

NOTES We shipped over 100 books out into the world, 56 of them returned a year later. A few were lost in transit or lent out, misplaced among friends. One was returned with it's pages completely blank but included an apology note. Some were deemed too valuable to their owners to be returned.

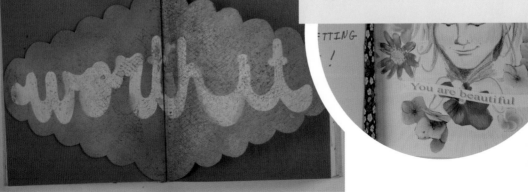

As with everything, I started small. I created six books that said "You Are" on the front cover, and "I Am" on the back. As the pages were filled in, the line of distinction between You Are and I Am became blurred. I passed around the books and they were filled up before I knew it. I created postcards with the same idea. These postcards filled walls in a few local galleries, and they were included in all SASE's. After sending out thousands of cards, I rounded up 30 more books to make another series. In the morning, I put out an invite to the community. If people wanted to become a book host for a year, they would just need to PayPal me the shipping cost to get it to them. By the end of the day, well over 100 people had sent me the shipping cost.

I must be careful what I wish for, especially with this incredible community. I quickly found as many blank books as I could get my hands on, sending out all different sizes and types of books. The host process was entirely first-come, first-served. No one received special treatment or status, and no one was asked to show samples of their work. They only needed the willingness to participate.

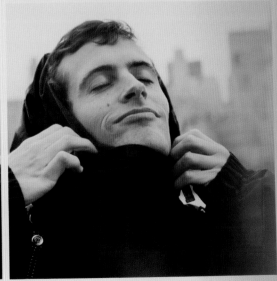

THOMAS DOZOL
-PORTRAIT OF MY IDENTICAL TWIN-
NEW YORK 2004

- We all need positive outlets. We feed off energizing and inspiring people who fuel our creativity. <u>Sometimes you have to spark the interaction</u> and get creative in your approach. Seek out projects others are doing that interest you. Inspire one another, and keep moving forward.

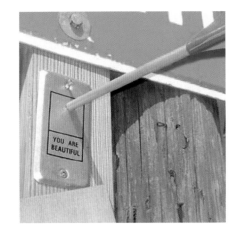

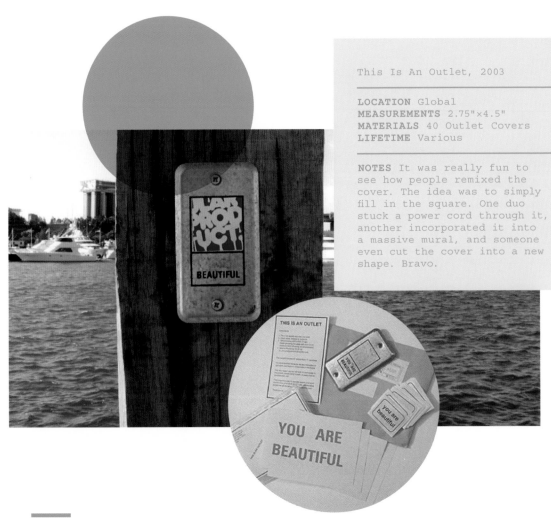

This Is An Outlet, 2003

LOCATION Global
MEASUREMENTS 2.75"×4.5"
MATERIALS 40 Outlet Covers
LIFETIME Various

NOTES It was really fun to see how people remixed the cover. The idea was to simply fill in the square. One duo stuck a power cord through it, another incorporated it into a massive mural, and someone even cut the cover into a new shape. Bravo.

I've always been intrigued by what other people are doing. I think it's amazing when people take the time to be creative or generous. When you can do both, that's a solid win in my book. I reached out to a few creatives that had been doing interesting work, and asked them if they wanted to take part. Everyone immediately said yes. I'm always amazed at how generous people are.

I chose a switch plate cover, much like the silver sticker in concept. It was something that could blend into daily life unnoticed. Ironically, what each artist did was so spectacular you couldn't help but notice it.

Sometimes, we all need an outlet.

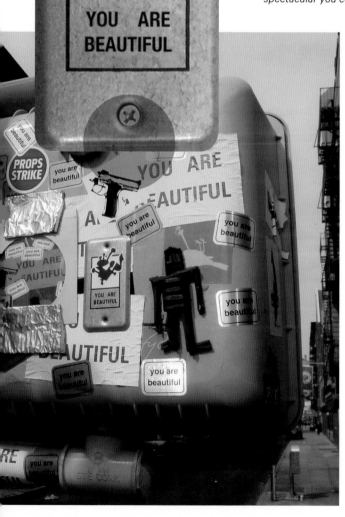

Define

E

your

N

E

ssɔɔns

Be confident and know you're doing incredible things. Know that your path is unique, and not a straight line. Know those bruises and scars show how you went for it, and never held back. Know you have no way of knowing what lies ahead, and that's the fun part.

Never hold back.

What's the answer? Love what you do and be incredible at it. Be so incredible that people can't help but smile. They might not exactly get it, but at the same time they can't argue that what you are doing isn't amazing.

Live Collaboration, 2013

LOCATION Chicago, IL
MEASUREMENTS 8'×20'
MATERIALS Plywood, Stencils, Paint
LIFETIME Alive & Well

NOTES The hundreds of people that came through the opening at the Green Exchange were invited to paint on the wall. The grand reveal occurred later in the exhibition, as hidden vinyl letters were peeled away to expose the message. This piece now lives at Threadless headquarters.

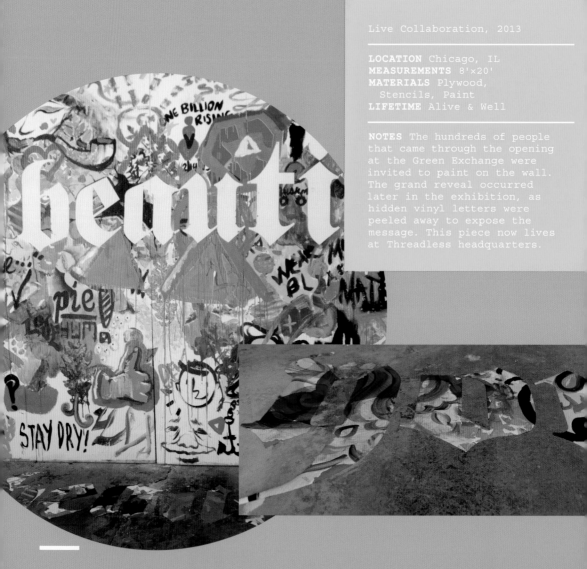

When you give gifts to others and the world, you never know how it will come back to you. But that's not the point. Give a gift to someone today expecting nothing in return. Step up to the challenge and be surprisingly selfless. You'll see — it's awesome.

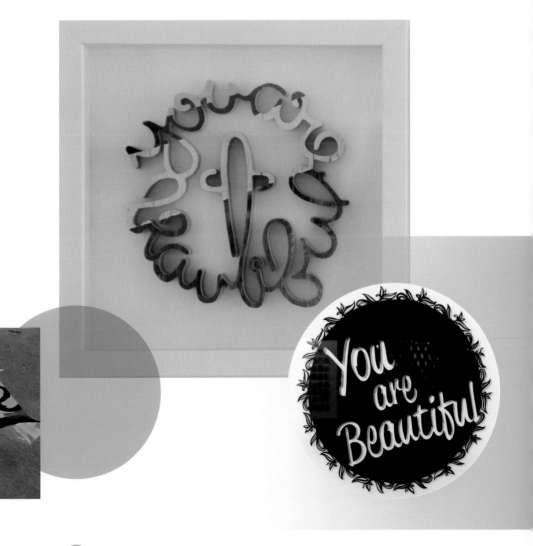

I was attending a leadership conference to hear Seth Godin speak. Sitting among 7,000 people, with over 150 thousand teleconferencing worldwide, I was rather excited. Seth was speaking on the subject of gifts when I unexpectedly heard him say, "Matthew Hoffman put an idea into the world." My mom, who was sitting right next to me, gasped out loud. (Yes, I was there with my parents).

Pictures of my work and You Are Beautiful installations began to stream across the massive projection screens. It was the first time I had ever been publicly linked to the project. I realized I had just been outed by an idol.

SETH GODIN: *Giving gifts. Going to someone and saying I am doing this for you, I am doing this with you, hoping you will spread it. Matthew Hoffman put an idea into the world. A very simple idea. Suddenly, it started spreading, it started changing people. And if you can give something to people to believe in, just give it to them, magical things start to change.*

As You Are, 2013

LOCATION Chicago, IL
MEASUREMENTS Various
MATERIALS Various
LIFETIME 4 Months

NOTES Over 31 designers and artists took their hand at creating gifts out of the message. One artist created calligraphy on the spot. Posters, cards, stamps, balloons, and much more were given away. It was an incredible evening, and no one left empty handed.

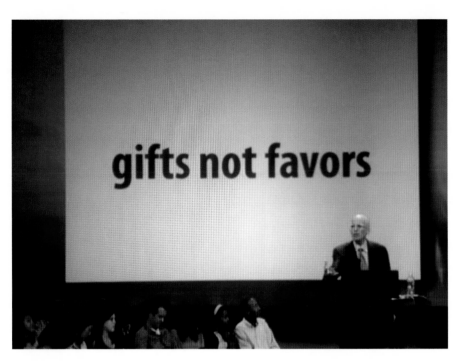

gifts not favors

Seth went on to
say that gifts truly
given, without
anticipation of
repayment creates
a deep connection.

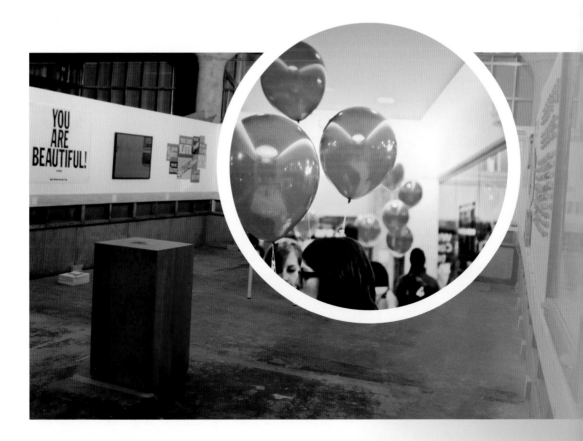

- **Say, "I did this."** Stand behind what you do and take responsibility. **Accept the credit or the blame, and be proud of what you believe in. Remember that no one is perfect, and reflect on the things you've done well. Focus on your strengths and harness them for the future.**

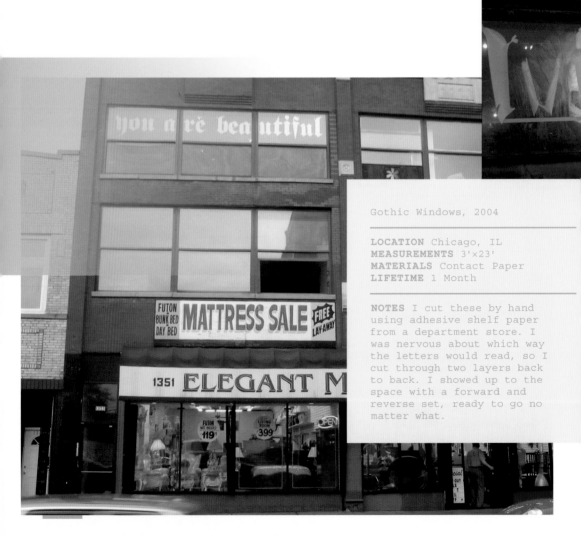

Gothic Windows, 2004

LOCATION Chicago, IL
MEASUREMENTS 3'x23'
MATERIALS Contact Paper
LIFETIME 1 Month

NOTES I cut these by hand using adhesive shelf paper from a department store. I was nervous about which way the letters would read, so I cut through two layers back to back. I showed up to the space with a forward and reverse set, ready to go no matter what.

This was the first place I had it written. I know from experience that it's easy to go off-course, to get busy or distracted with other things. Interest can wane, especially when the project hits the real world. I knew this message was so critical that I had to hold myself accountable to it.

For many, many years, this message was completely anonymous. I wanted people to focus on the message itself and not who was behind it. To this day, it still makes me slightly uncomfortable that everything is so transparent. I don't have all the answers — no one does. I'm just one person who had an idea, brute determination, and a sustained belief.

It's the community who supported it, nurtured it, and brought it to where it is today. The community is the driving force, and they deserve all the credit. If someone found a sticker for the first time and shared it, I'd be a little sad to hear of anyone telling them "That's Matthew's thing." No. This is your thing. Your moment. This is for you. Enjoy it.

Enjoy the message for what it means to you.

The moment when another person puts their trust in you to deliver is a big deal. We all know what it's like, and we've all been at the receiving end with both good and bad experiences to share. The golden rule is a good one, but take it a step further and treat others as you would never in your wildest dreams expect to be treated. Some rules aren't meant to be broken, just made better.

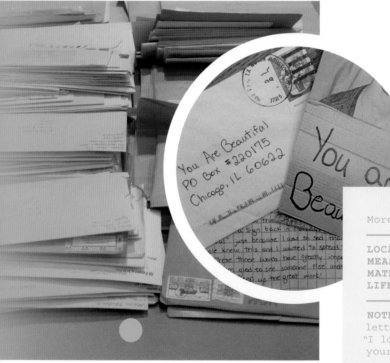

More Letters, Since 2002

LOCATION Chicago, IL
MEASUREMENTS Various
MATERIALS Envelopes, Love
LIFETIME Ongoing

NOTES One of my favorite letters from a grade schooler: "I love waffles, and I love your message."

I started this project by making a single page website where you could send in a self-addressed stamped envelope to receive stickers. Suddenly, I was getting so much mail that I had to rent a P.O. Box. I kept getting calls from the postmaster, complaining that the box was always too full, and if it continued, I would need to rent a larger box. I was thrifty, and just checked it every morning.

It was packed with letters from people sharing how they found the sticker and what it did for them in that moment. But are you ready for this? Almost every letter went on to say, "Send me as many stickers as you can because I'm going to spread these everywhere." They got so much out of this message that they wanted to make sure others got to experience it as well. They became ambassadors of the message and are fully responsible for carrying and spreading it around the world.

And with great inspiration, comes great responsibility. Many heartfelt letters have gotten a personal response from me. I've written thousands of letters over the years because I know how important that moment is to the receiver.

"How do I get these stickers?!"

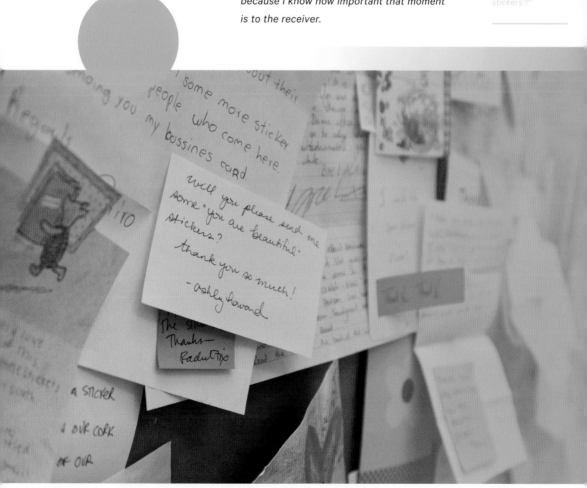

BE

BE

you

BE SPECTACULAR... **BE YOU**

•

We need you to be spectacular, larger than life. We need you to be your own parade.

Ask yourself "Why not?"

Let's do and create things that leave nothing the same. Let's give gifts and bring hope and wonder to those we encounter. Let's be human to each other, constantly striving to over-deliver. Let's change the mindset from, "Why?" to "Why wouldn't I?".

Even More Letters, Since 2002

LOCATION Chicago, IL
MEASUREMENTS Various
MATERIALS Envelopes, Love
LIFETIME Ongoing

NOTES I've saved each and every envelope or box top that has been sent over the years. At first glance, you might think I have a hoarding issue, until you take a moment to look at the incredible works within the collection.

Dazzle us. Stop us in our tracks. Do the things that no one else has the courage to do. Do the things you used to have the courage to do, but have replaced courage with excuses. <u>Remember what it was like to believe everything was possible.</u> And do it — even something small, just to break the ice. It's these little things that add up to make a huge difference.

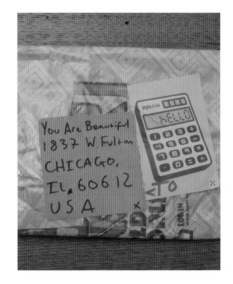

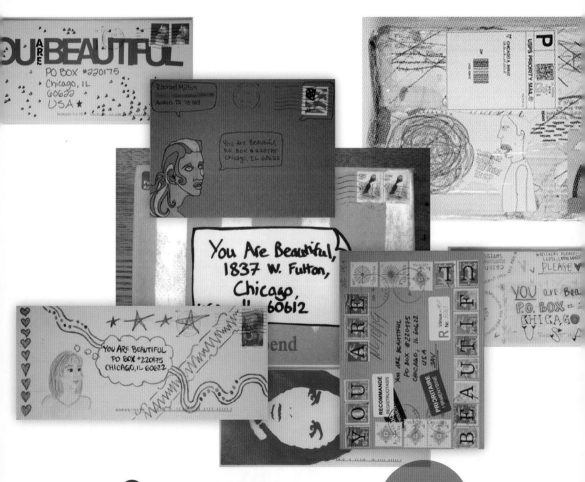

On a chilly fall day, I drove to Waldron, Indiana (population: 804). Outside the elementary school, it was a gray day with the flags still hung at half mast due to a recent school shooting. Inside, it was another story. The entire school was bursting with energy. At a pep rally held in the gymnasium, 300 children sat rapt on the floor waiting to see the grand unveiling. Each child had drawn their own portrait and those pictures were tiled together in large letters. I told them, "You made this…and this message will be here forever."

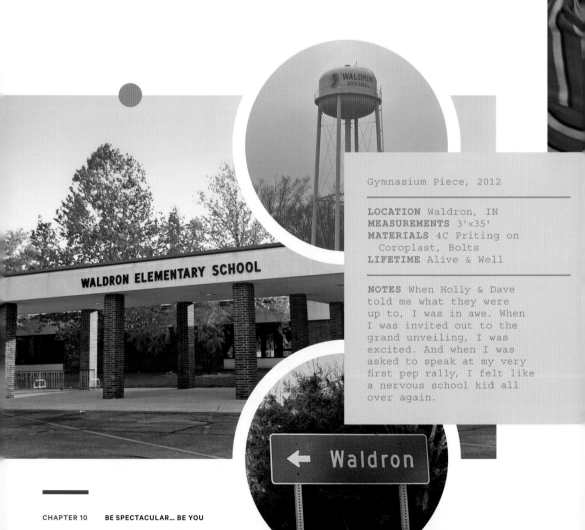

Gymnasium Piece, 2012

LOCATION Waldron, IN
MEASUREMENTS 3'x35'
MATERIALS 4C Priting on
 Coroplast, Bolts
LIFETIME Alive & Well

NOTES When Holly & Dave told me what they were up to, I was in awe. When I was invited out to the grand unveiling, I was excited. And when I was asked to speak at my very first pep rally, I felt like a nervous school kid all over again.

WALDRON ELEMENTARY SCHOOL

← Waldron

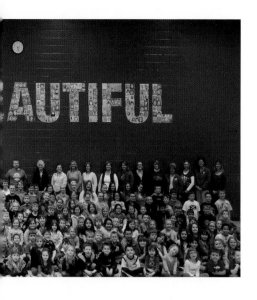

After the unveiling they all ran up to the piece, wildly pointing at their contribution. The school wanted to celebrate their kids. They wanted a reminder for every kid who fell short, missed a goal, or didn't finish first. That it was OK to be themselves, and be spectacular in their own way.

Dream big.

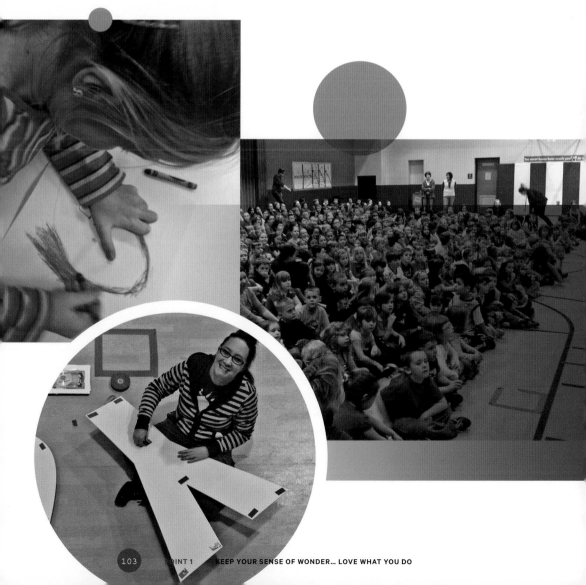

• When big things need to happen, it's time to band together and step up for the challenge. <u>We count on each other to help take on incredible things.</u> It's fun to dream big. It's inspiring to lose yourself in "What if?" It's another thing entirely to put those ideas into reality, and for that we need each other.

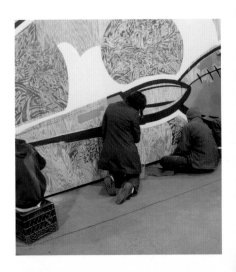

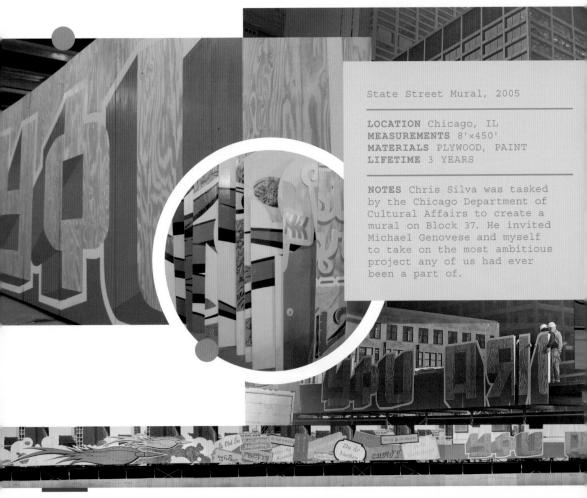

State Street Mural, 2005

LOCATION Chicago, IL
MEASUREMENTS 8'x450'
MATERIALS PLYWOOD, PAINT
LIFETIME 3 YEARS

NOTES Chris Silva was tasked by the Chicago Department of Cultural Affairs to create a mural on Block 37. He invited Michael Genovese and myself to take on the most ambitious project any of us had ever been a part of.

Painting in the freezing cold, we created a piece of Chicago history. We were situated under the Roosevelt Road Bridge in the Chicago Public Art Storage Warehouse. To fight the cold, we shoved heat packs in our gloves, wore three or four sweatshirts, and even brought a few space heaters. We would take turns standing next to them — but it didn't matter. You could barely feel a thing.

We were painting and cutting over 100 4'×8' panels to create a collaborative piece that would be over a block long. We had a huge volunteer pool from Craigslist, and we wouldn't have been able to do it without them. Because of the severe weather, many volunteers came for an hour, never to return. I didn't blame them one bit.

In the end, the working conditions didn't matter because we made it happen. We knew we were doing something bigger than ourselves. We knew it was worth it. This piece was in the center of Downtown Chicago for three years while a skyscraper was being built.

Dream together.

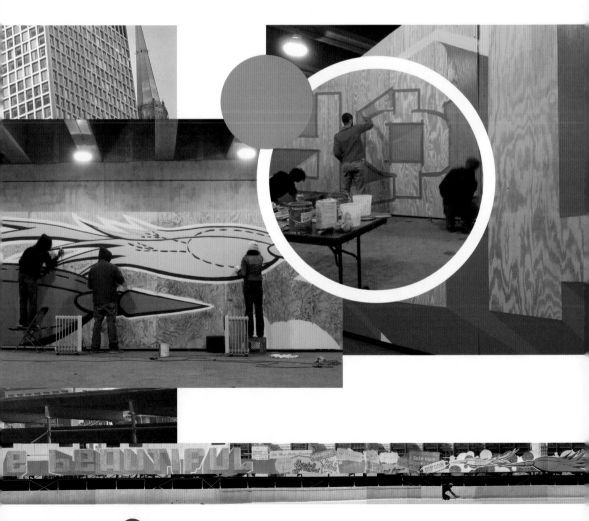

- We're here because we want to have incredible stories to share, and people to share them with. We want amazing memories. We're not looking to just work a job, fill up a savings account, and buy fancy things. We want more. How do you get more? Be spectacular. Be you.

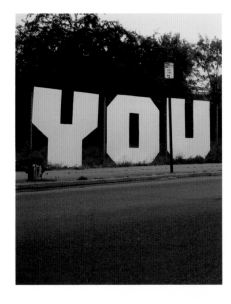

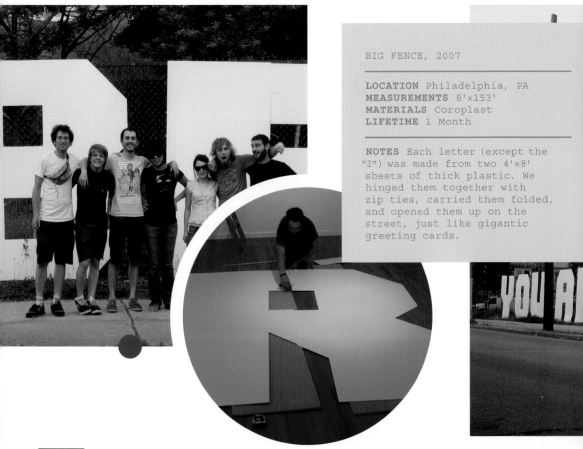

BIG FENCE, 2007

LOCATION Philadelphia, PA
MEASUREMENTS 8'×153'
MATERIALS Coroplast
LIFETIME 1 Month

NOTES Each letter (except the "I") was made from two 4'×8' sheets of thick plastic. We hinged them together with zip ties, carried them folded, and opened them up on the street, just like gigantic greeting cards.

We had so much fun putting this piece up and sharing it with the world. Look at the scale of it! Each of these letters are 8'×8'. I still laugh at the thought of someone driving by, turning the corner and seeing a piece like this completely unexpected. It's mind blowing.

Due to the size, we only had enough space to lay out one letter at a time. A crew of us carried the letters a few blocks to the fence. Even though it was hard work, the excitement was palpable. These youngsters were shouting, "Here we go!" and, "Let's do this!" I think it was the combination of spreading such a powerful message and doing something a little rebellious.

I wish I had video footage of the public's reactions as they came around the corner. I'm sure there would have been some entertaining and inspiring faces captured.

"Let's do this!"

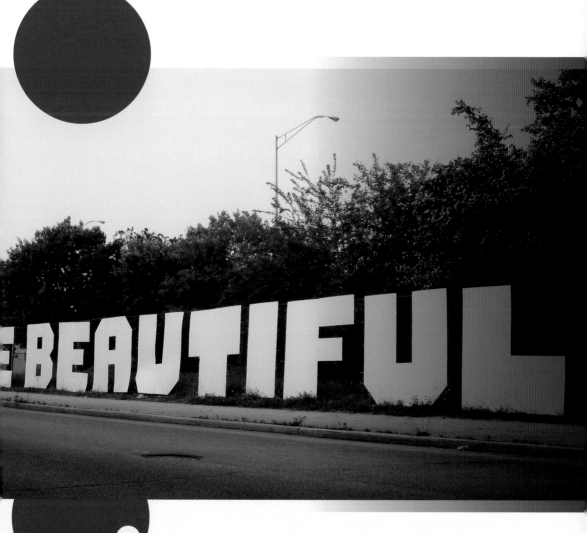

- **Now it's up to you. This is your thing, your moment. Tell your story. Create moments that change things forever.** <u>Peel, stick, and share.</u>

Here you will see a small selection of photos from more than a million stickers, and countless community projects from the past decade. This message has reached most cities on every continent of the world. These are people "being human" to complete strangers — quietly giving, without fanfare, and making a small difference that adds up to a massive movement.

Now you.

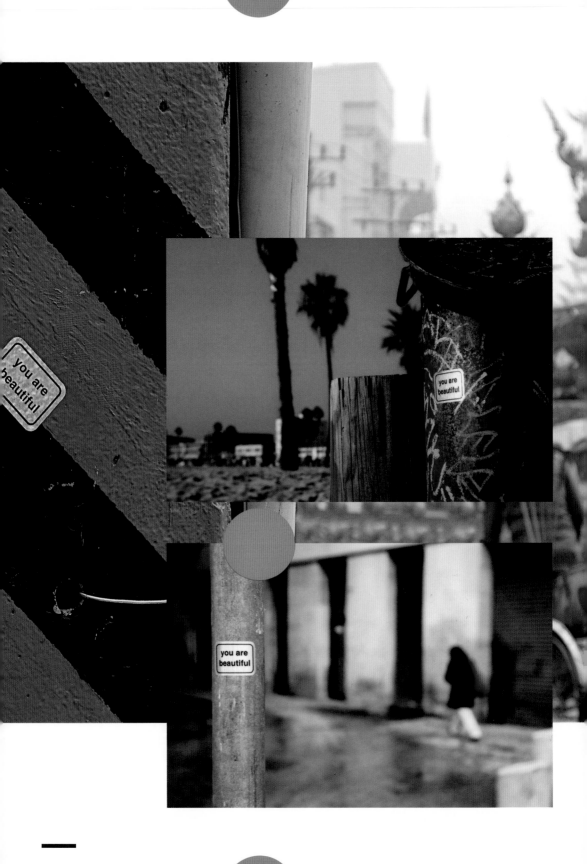

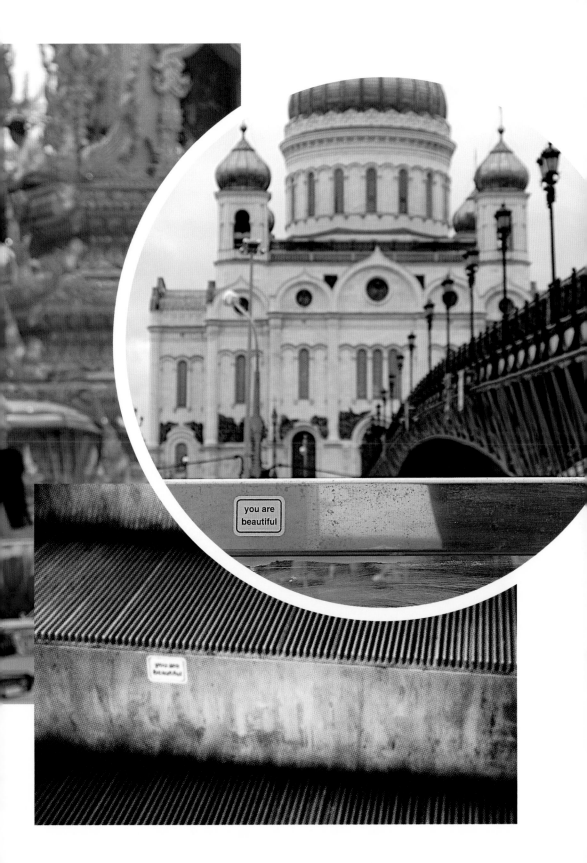

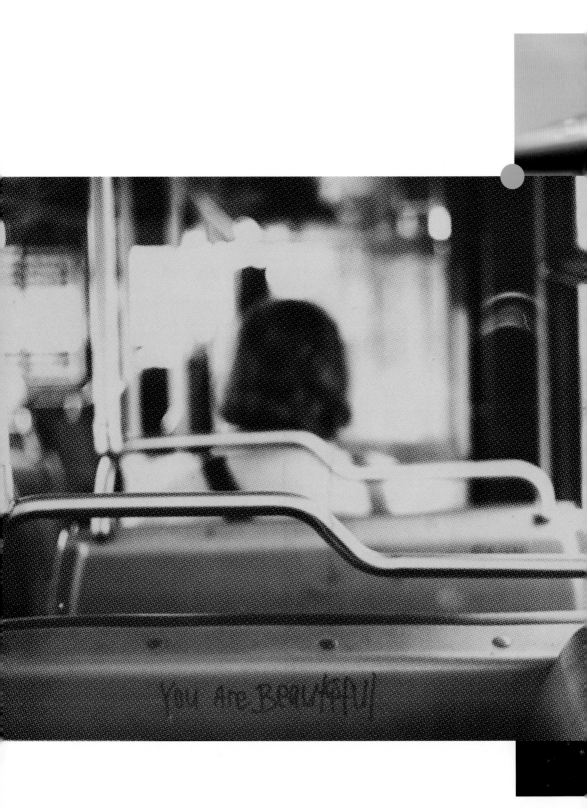

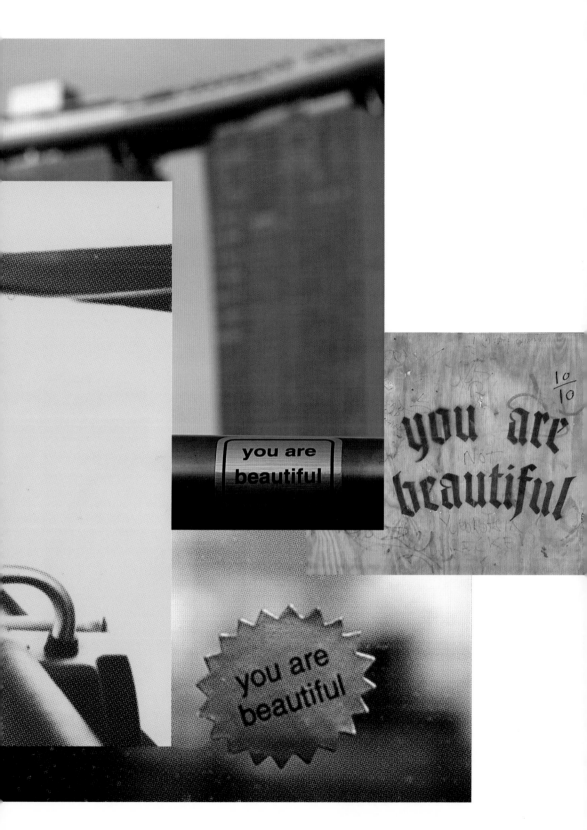

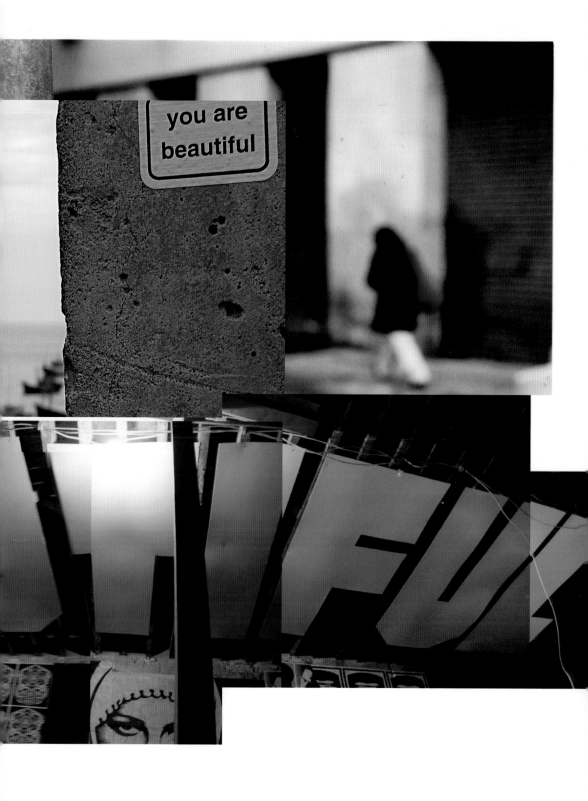

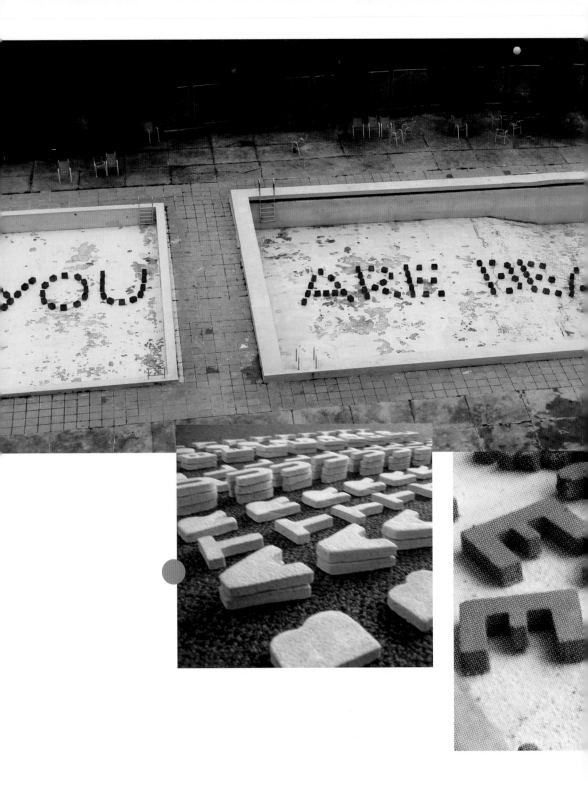

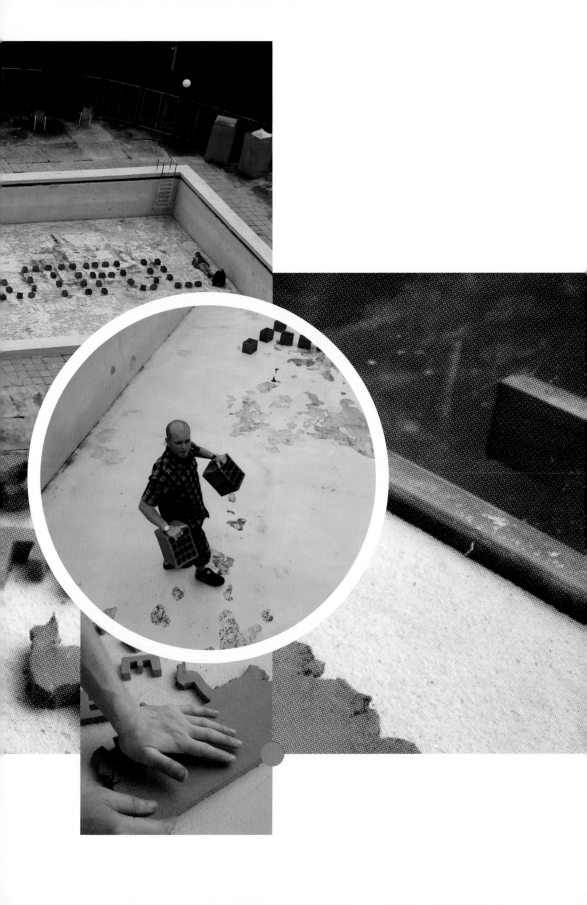

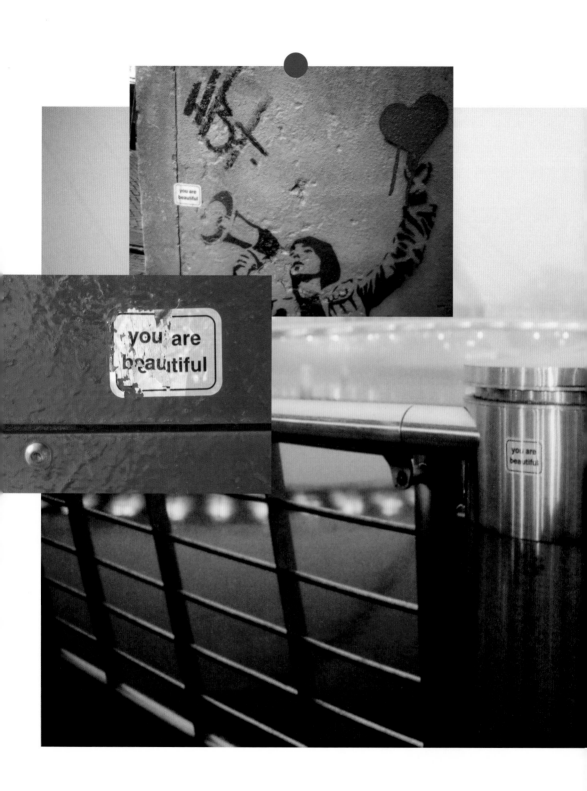

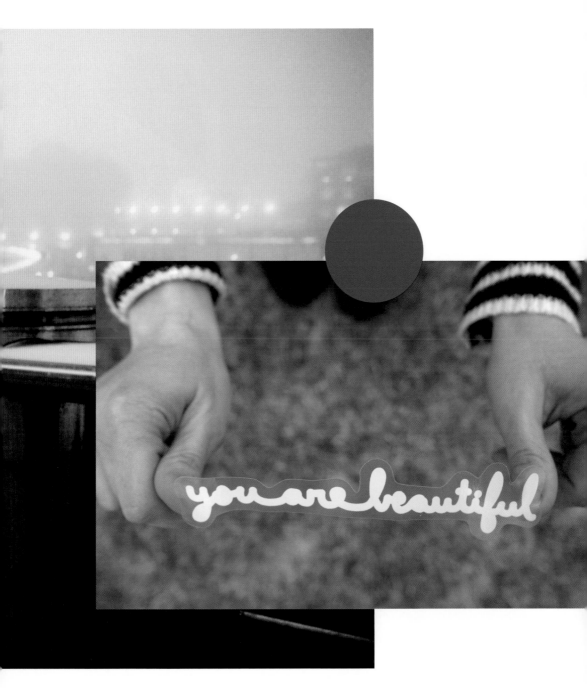

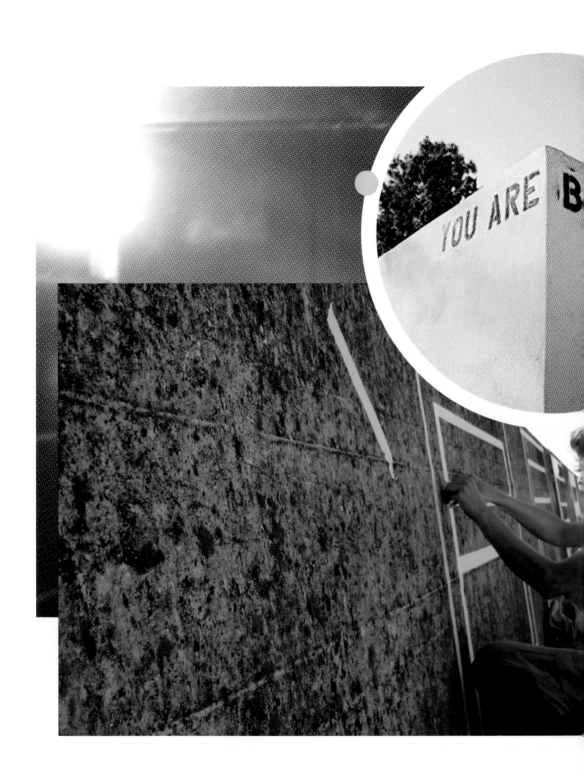

YOU ARE B

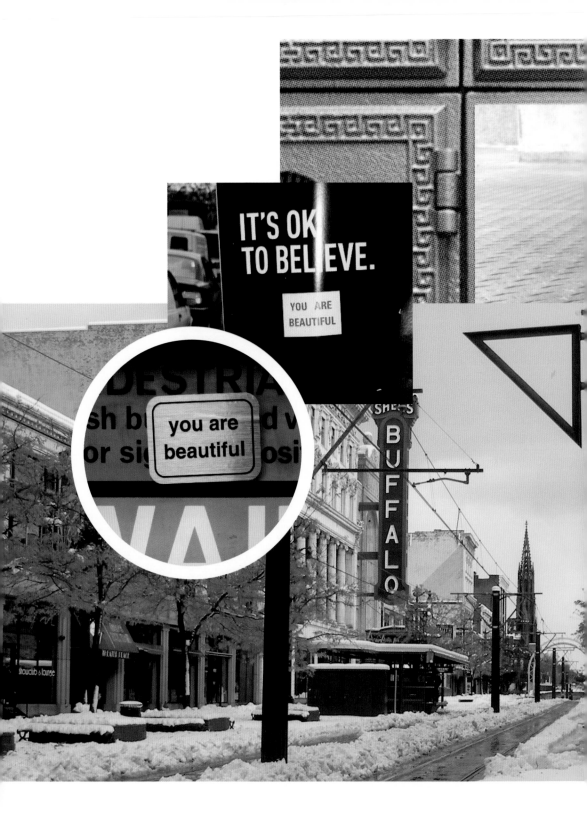

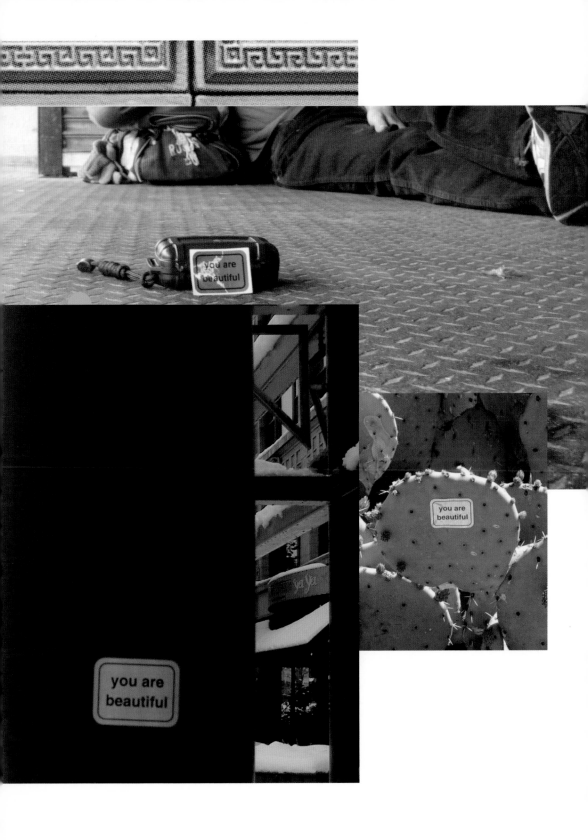

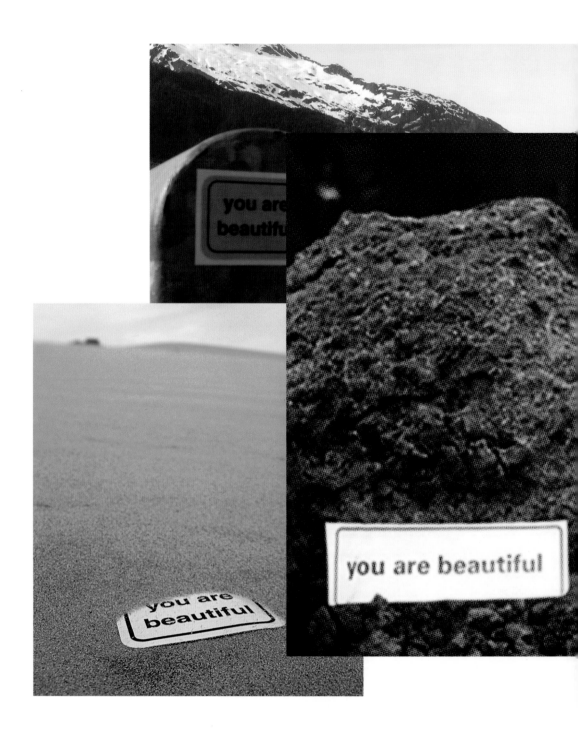

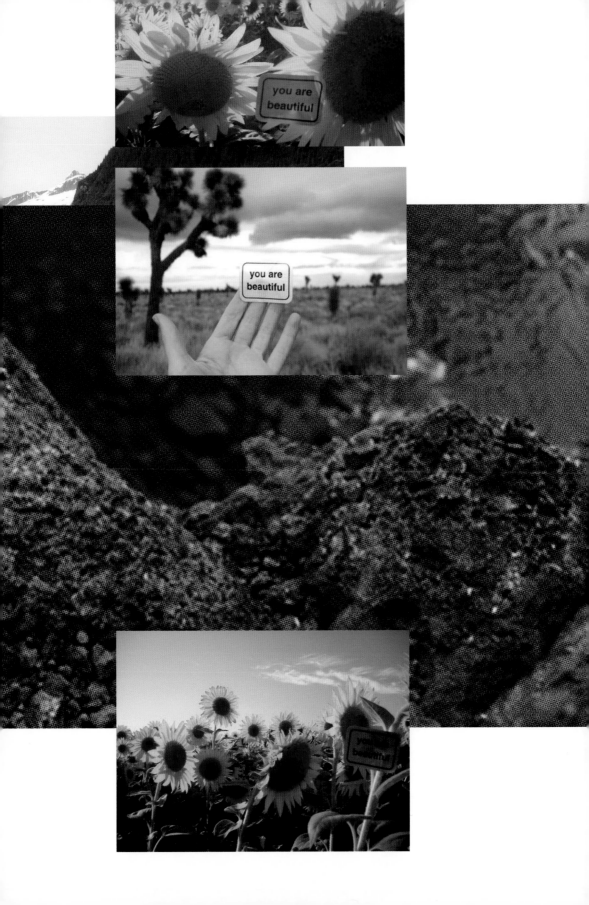

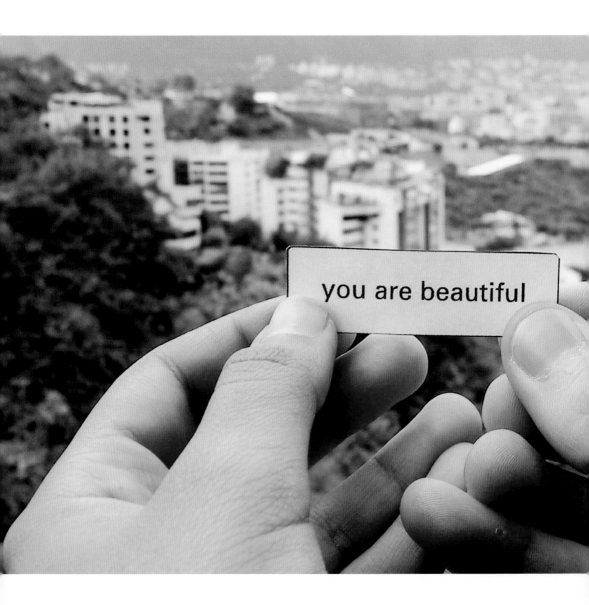

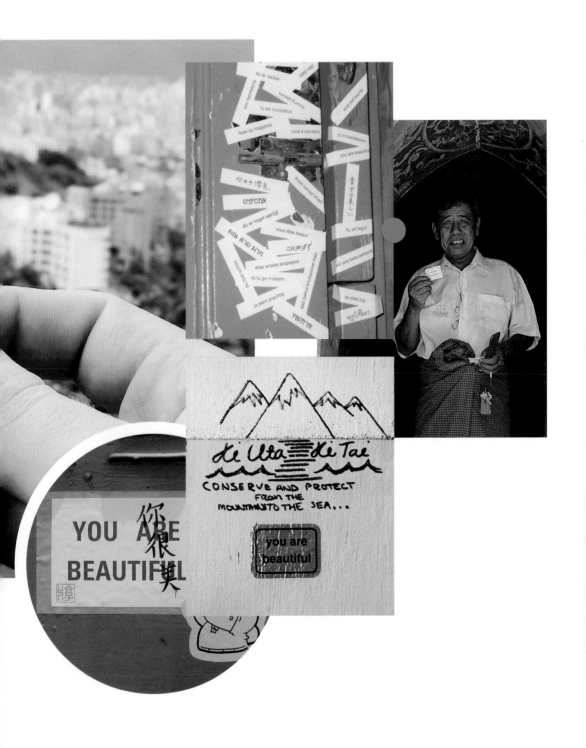

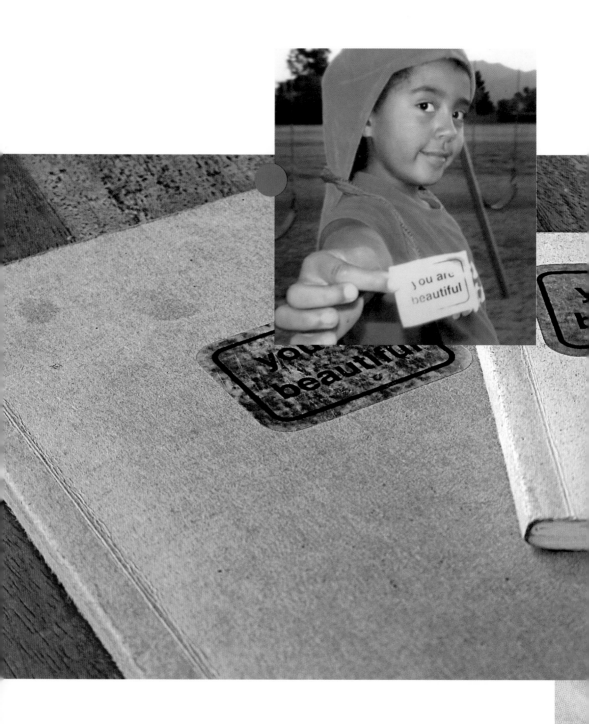

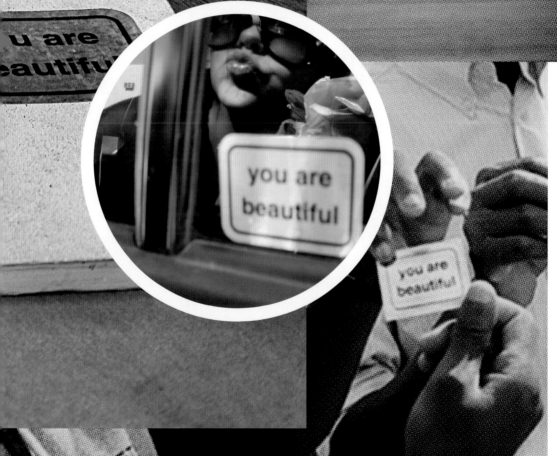

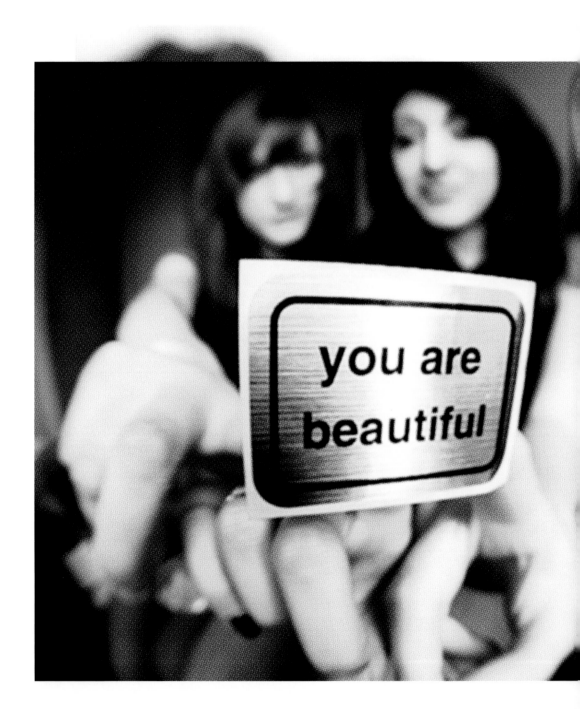

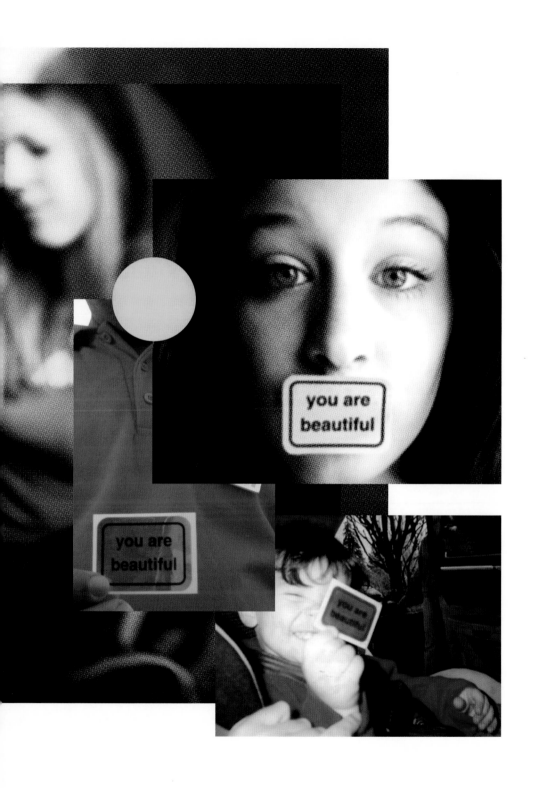

We did this book like we've done everything in this project: with you, the community. We did it together, and in our own way. More than 700 of you jumped at the opportunity to make this happen, and backed this project on Kickstarter. Together you all rose to the occasion and overfunded it, well before the deadline. We couldn't have done this without you.

A — AUTUMN

Aaron Krach
Aaron Smith
Abigail Irwin
Adam Starbuck
Adam Kruvand
Adam Lawrence
Adam Stacey
Adam Ward
Adan Resendiz
Adrien Bono
 Aeugler
Alana Arseneault
Alberto Hardt
Aleks Jimenez
Alex Bohs
Alex Fuller
Alex Ha
Alex Synge
Alexis van Dijk
Ali Balutowski
Alicson
Alisa Wolfson
Alison Jacobs

Alison Yard
 Medland
Allison Bannister
Allison Hall
Amanda Cagan
Amanda Kelly Foran
Amber Hunter
Amber E Staab
Ammiel Mendoza
Amy Allred
Amy Buckler
Amy Ciavolino
Amy Jo Johnson
Amy Mayfield
Amy Rowan
Amy Schiffer
Amy Segebarth
Andrea Mason
Andres Luevanos
Andrew Franciosa
Andrew Lee
Andrew Tibbetts
Andy Luce
Andy Schwegler

Angelika Strong
Anita Birsa
Ann Karash
Anna
Anna Piszczor
Anne Baldwin
Anne Holub
Anne Petersen
Anne Rossiter
Anne Serr
Annie Peter Osman
Annie Ranttila
Annie Richardson
Anthony Lewellen
Antionette Carroll
Antonio García
April Yvonne
 Muller
Arianne Roxa-
 Anderson
Aronne Merrelli
Austin Brackett
Autumn Wacaster

B — BYRON

Barbara Graves
Barbara Picco
Beak
Becca Peryea
Becca Vega
Becki Fuller
Ben Arrington
Ben Haase
Beth Nicole
 Sakshaug
Bev Wieber
Bill Scanlon
Billy
Bindike

Born A Jee
Brad Burge
Brandon Jablonski
Brenda Bergen
Brenn Stacey
Brent Bruynseels
Brent Gruel
Brett Jacobs
Brian Bain
Brian Dockter
Brian Grenz
Brian Hagy
Brian Hensley
Brian McCann

Brian Stern
Brian Wyrick
Brianna Gordon
 Fricke
Bridget McAlonan
Brigid Eduarte
Britt
Brittany Ransom
Brittany
 Skwierczynski
Bronwyn Krix
Bud Rodecker
Byron Flitsch

C — CYNTHIA

Cade Peterson

Candace Hoffmann

Cargan Lu

Caryn Michael
Cassie Hester
Catie Burrill
Chad Velk
Chank Diesel
Chanon Nick
Sermchief
Charles Borowicz
Charlotte Sarah
Clark
Cheri Gearhart
Chicago The
Beautiful
Chinwe Onyeagoro
Chris Apap
Chris Wacaster
Chris Ruwoldt
Chris Schwing

Chris Silva
Chris Stratford
Chris Wiegman
Christen Carter
Christian
Picciolini
Christine Evans
Christena Hoffman
Christine Lee
Christine Lega
Christopher A
Franco
Christopher
Gianelloni
Christopher Hiltz
Christopher Jobson
CJ Coombs
Claire

Claire Molek
Clara Alcott
Clay Stelzer
Cody Hudson
Colby Hamilton
Colin Cronin
Colton Day
Connie Keith
Cora Poage
Cori Kindred
Corinne O'Connor
Courtney Tan
Craig M. Clark
Cristina Lalli
Crystal Silver
Curtis Myers
Cynthia Rodarte

D — DYLAN

Dale George
Damian Gordon
Damien James
Dan Kelter
Dana E. Blaesing
Danai Samuriwo
Daniel Barojas
Daniel Marrazzo
Danielle Rappaport
Danielle Romano
Danny Cantu
Dara Perales
Darcy Scott
Darren McPherson
Dave Combs

Dave O'Connor
Dave Rabin
David Hooper
David Marshall
David Scott Hay
David Sieren
David Willis
Dawn Hancock
Dawn Newbrough
Deb Striker
Debbie Adele
Cooper
Debbie Block
Deborah Alden
Deborah Sherwin

DeForrest Warren
Dewi Maile Lim
Diana Hakenen
Diana L. Goulding
Domagoj Guscic
Domenico Commisso
Donna Piacenza
Dorota Haley
Napiorkowska
Dovid Negin
Duane Hoffman
DuShaun Branch
Dylan B. Lindholm
Dylan Goodrich

E — EUGENE

Earl Garcia Birch
Elaine Chernowv
Elan Auman
Elias Derwisj On
Tariqa
Elise Zelechowski
Elisiane DaSilva-

Taylor
Elizabeth
McKinstry
Elizabeth Clay
Elizabeth Weislak
Ellen Beth Stollar
Ellen Gradman

Emilie Jost
Emily Van Hoff
Emily Green
Emily H
Emily Hoffmann
Emily Lange
Emily Rush

Eric Damon Walters	Erica Susanto	Erin Borreson
Eric Dobbins	Erik Sjostedt	Erin Waser
Eric Wagner	Erin Blaesin-	Ethan Bodnar
Eric Wallach	 Miller	Eugene Leung

F — FRED

FangWoei Chan	Flock Shop	Francine Klotz
Felix Jung	Frances MacLeod	Frankie
Fernando Holguera	Francesca Broersma	Frankie
Flores	Francesco	 VanNostrand
Finn Røgeberg	 Morassutti	Fred Marshall

G — GWEN

Gabriel Coder	Gina Duran	Greg Moul
Gary Musson	Gina Focareta	Greg Ojala
Gaudin Jules	 Evans	Greg Williams
Genevieve Daigle	Glittermouse	Gregory D Hoskins
Genevieve Norman	acefindsgoodness	Gretchen Hoffman
George Stancu	Graham Giovagnoli	Greysoul Studio
Gidget Clayton	Greg Calvert	Gwen Edwards

H — HOLLY

Hannah Foutz	Heather Booth	Hiroki Hagiwara
Hannah Kaiksow	Heather	Hjalmar
Hannah Maximova	 Christensen	 Kristiansen
Hannes Papenberg	Heather Stahl	Holly Combs
Happy	Heidi Fledderjohn	Holly De Saillan
 Collaborationists	Heiko Kleiner	Holly Greenhagen
Hayley Heaton	Helen Lee Reid	Holly Nyannyannyan
Heather	Hillary Lewis

I — IVY

Ian Schulz	IndieClass	Isabel Lee
Ian Sienicki	IPaintMyMind	Ivy Hover

J — JUSTIN

Jeff Hapner	Jacquelyn	Janine Melzer
Jack Chappel	 Rubashkin	Jaren Cornwall
Jack Ebensteiner	James M. Adam	Jason Clary
Jack Schroeder	James Spangler	Jason Cobb
Jackie Lauger	James Williams	Jason
Jackie Pierson	Jamie Davis	 Frohlichstein
Jacob Zionts	Jamie Dihiansan	Jay Miller
	Jane Kintz	Jb Daniel

This book is for you. Together we made it real.

Jean Etienne
Jean Hagan
Jean Wnuk
Jebkam
Jen Marquez
Jenna Mendez
Jennifer Battis
Jennifer Fennell
Jennifer Monroe
 Fliegel
Jennifer Wyrick
Jennifer Monzon
Jennifer Reeves
Jennifer
 Rutherford
Jennifer
Schaffroth
Jeremiah Ketner
Jeremy Lum
Jeremy Schulz
Jerry Gabra
Jerry Steele

Jesse Heiman
Jessica Buttermore
Jessica Garcia
Jessica Gorman
Jessica Guinn
Jill Salahub
Jillian Pilon
Jim Harbison
Jim Schulz
Jince Kuruvilla
Jody Schiesser
Jodi Clark
Joel Mynsberge
Joerg Metzner
Joey Vizcarrondo
John
John Bowles
John Giordano
John Handwerk
John Hergenroeder
John Pobojewski
John Skarha

Johnathon Strube
Jon Lansing
Jonathan Cohn
Jonathan S.
 Brothers
Jori Keet
Joseph Lappie
Josh Ehart
Joshua Chan
Joshua Heyburn
Joshua Rogers
Josie Bounds
Julia Blackmon
Julia Haw
Julia Parnell
Julia Phoebus
Julie Heyduk
Julie Jackson
Julien Lapensée
Justin Keith

K — KYLIE

K Waterloo
Kaisha
Kaiulani Winter
Kalene Rivers
Kamaile Mattix
Kandy Christensen
Kanardo
Karen Lee
Karin Montemayor
Karen Stigall
Karissa Ringel
Karl Koett
Karl Okerholm
Kat Mason
Kate Butler
Kate Ebert
Katherine
 Darnstadt
Katherine Villamin
Katherine

Wasserman
Katy Schafermeyer
Kay Martin
Keely Godwin
Keith Sadler
Kelli Langdon
Kelly Bruce
Kelly Kaminski
Kelly Knaga
Kelly Lynn Jones
Kelly Noah
Kelly Poole
Ken Allen
Ken Christianson
Ken Talbert
Kendra Laflin
Kenny Smith
Kevin A Pence
Kevin Mioduch
Kevin Pajewaski

Kevin Tao
Kier Keeks
Sinclair
Kik McNally
Kim Granstrom
Kimberly Knight
Kimberly Miller
King is a Fink
Kira Lantz
Kongiro
Kate Reilly
Kristian Lemar
Kristen Lehmann
Kristen M. Karvala
Kristi Redington
Kristin
Kristin Farr
Kristy Plumridge
Kyia Downing
Kyle LaMere

Kyle Bailey Kyle Fletcher Kylie Tien

L — LYNN

Laura Kelly Linda Weber Lou Weber
Laura Rosseter Lindsey Shepard Louis Riley
Laura Linsey Burritt Louise Rouse
Schillemans Lisa Gibson Lucy Rice
Laurence Fritts Luis Martinez
Samuels Lisa Jakobsen Luna Park
Leah McKay Lisa Korpan Lunchtime
Leana May Lisa Weiss Studios
Leanne Abramo Liz Aldag Lynda MacInnes
Lee Brown Liz Rose Chmela Lyndon
Leeza David Lizabeth Valicenti
Lena Kim Barclay Lynlee Ford
Leslie Adams Loddie Foose Lynn Rossiter
Leslie Alter Lola Michaels Lynn Young
Lexi Roberts Lola Wright
Libby VanWhy Lori Baranoski

M — MORGANE

Madeleine Ong Marta Hanson Melissa Cruz-
Madison White Martha Barrios Campbell
Maggie Taylor MartinJon Melissa Francis
Mairead Case Marty Bird Mert Iseri
Maja Zuta Zovko Marvin Dollente Michael Ashley
Marcelo Torres Mary Kananen Michael
Llamas Mary Morse Balthazor
Marcus Mary Perkins Michael Berger
Hartsfield Mary Schmidt Michael Knowles
Margaret Boyle Masaki Michael Pecirno
Margaret Gere Nishikawa Michele
Margaret Kujawa Matt Avery Cleaveland
Margot Matt Leigh Michelle Olsen
Harrington Matthew Michiel Oele
Margot Fahnestock Mike A Mendiola
Rappaport Matthew J. Mike Dornseif
Maria Slovakova Wetzler Mike Hollibaugh
Marie Nelson Meg O'Connor Mike Joosse
Marisa Ruiz Megan Craig Mira Lyon
Marissa Lynn Megan Hodsdon Miranda Katz
Frattini Melanie Johnson Miriam Kates-
Mark Dudlik Melinda Goldman
Markus Widmer Fernandes

Misha Maynerick
Blaise

Mitch Finzel

Monet Richter

Monica E
Stevens

Monica Pozzi

Monika Sok

Morgane Guyader

N — NORMA

Nancy Flanigan

Nancy King

Naomi Van Tol

Natalie

Natalie
Baribeault

Natalie
Skwierczynski

Nathan J Anderson

Nell Taylor

Nella Synge

Nelson Kahikina

Nichole Ciotti

Nick Adam

Nick Marrazza

Nick Montgomery

Nick Reed

Nick Vargo

Nicole Eversgerd

Nicole Humphrey

Nicole Kibert

Nicole Weissman

Nicolette Michele
Caldwell

Nikki Alcala

Noah

Noel Drumbor

Norma Jean Lopez

O — OSCAR

OCDesk

Ohn Ho

Oliver Hild

On Look Films

Oscar Arriola

P — PUBLIC

Page Remmers

Pam Olson

Pamela Daley

Patricia Matei

Patricia Northrop

Patrick Hug

Paul Webb

Paul Colombo

Paulette
Eyvazzadeh

Paul Hirsch

Pe Auroussea

Pedro Madriz

Peggy Ludwick

Peter Boerhout

Peter Frazier

Peter Schmidt

Phil Jonas

Phil Jonas

Poetry

Poppy Spencer

Public Media
Institute

R — RYAN

Rachael Winter

Rachel Bryant

Rachel Heinrich

Rachel Holkner

Rainbow Weldon

Ralph Hoffman

Ranee Wu

Rebeca Mojica

Rebecca Lo

Rebecca Ann

Rakstad

Reina Takahashi

Renee Robbins

Rick Valicenti

Rob DiMartino

Robby Adams

Robert C. Cage II

Robin Dunne

Robyn Paprocki

Rocky Santaferraro

Ruth FitzHarris

Ryan Frazier

Ryan Hipp

Ryan Russell-
Timbrell

S — SVEN

Sabrina Scandar

Safi Ali-Khan

Sam Hunter

Sam Rosen

Sami Johannes
Niemelä

Sami Nerenberg Scott Stratten Soiled
Samuel Desaulniers Scott Thomas Something's Hiding
Samuel Sean Passean In Here
 Fuggenthaler Yannell Soo Young Lim
Sandy Irani Seaira Combs Spudart
Sara Frisk Sebastian Bunney Stacey Boyd
Sara Korbecki Sergey Safonov Stephane Rowley
Sara Wright Seth Kravitz Stephanie Keller
Sarah Atteveld Seth Mooney Steven Feuerstein
Sarah Farahani Seth Godin Steven Frost
Sarah Ford Shahid Sarker Steven Hudosh
Sarah O'Neill Shannon Downey Steven Murphy
Sascha Rummel Shannon Loucks Sue Lingl
Scott Sharon Fickeissen Sumedh Deoras
Scott Hebert Shawn Smith Sunshine
Scott Moore Shyla Jannusch Susan Chiara
Scott Reinhard Simon Silva Jr Susan Czechowski
Scott Rench Sofia Pietrella Sven Olaf Nelson

T — TYSON

Taleen Kalenderian Thorsten Bösch Tony Francesconi
Tanner Woodford Tim Stotler Travis Lampe
Tatiana Canaval Timothea Canny Trev Pierce
Tatjana Thorne Timothy Pigott Tripler Roden
Ted Burdett Tina Tripler Roden
Tehani Wessely Tina Kotrych Trish Garcia
Terri Bernsohn Tira Foose Trish Harris
Therese Hedwards Tom Burtonwood Tuur
Thoma Daneau Tom Fennell Tyson Steele
Thomas Callahan Tony Brasunas

U — VLAD

Una McGurk Victor Carreon Virginia Ahren
Vaido Vähk Victor Saad Cook
Varick Rosete Vinh Le Virginia Miller
Veva Silva Vlad Ionescu

W — WILLIAM

We did this.

Walter Mitty Will Berg William A. Franz
Werklife Will Miller

X — ZIA

Xavier Vives Riba
Yolanda Thornton Zac Gowen Zia Laura

You're stoked. Excited. Amped. You're smiling ear to ear, and you're about to change the world. You might be sitting on your couch, at your dining room table, in a coffee shop, or on a train or bus. Everything is so clear, and you're ready.

You're going to start now, take risks, share yourself with the world, work with others, be open, and make an impact. You've figured out who you are and what you want to do. You're never looking back.

But in a few hours, or tomorrow morning, here's what might happen: You can't find that pad of sticky notes. The printer jams. You've lost that marker that would be perfect for this. You try to put something up and the wind whips it away from you. You hand something to a person walking by on the street and they look at you like you're an alien. The trip to the store to buy supplies leaves you with buyer's remorse. The friend you were going to do this with backed out, and you're sitting at home stumped what to do next.

How do I know this? I speak from experience.

Know that many of these things (and other unpredictable events) will happen. But some of those unpredictable events are going to knock your socks off. You have no idea what lies ahead. It's going to be hard work, but it's going to be incredible.

So go out there and do something right now. Or even stay in. Put something on your front door. (As I'm typing this, I just took a marker and wrote, "I'm glad you're here" on a piece of typing paper and taped it to my front door. Done.) Do something that guarantees you a victory.

It's going to be hard work, but it's going to be incredible.

And after a few days or weeks, when your momentum lags, when your daily life is a grind again, when you're a little worn out, and you wonder why you work so hard, with such little reward... Pick this book up again, and flip through it.

Use these stories to guide you through your unique journey. We're here for you. So go. Right now, (I'm making hand gestures, pushing you away).

We'll be waiting for you, right where you left us.

Pick this book up again, and flip through it. Use these stories to guide you through your own unique journey. We'll be waiting for you, right where you left us.

See you soon.

<u>To every person who has put up a sticker, made an installation, or sent in a letter</u> — whether you have been here since day one, or have only been here for a day. Without you, none of this would have been possible, and I'd just be a guy living in Chicago with a garage full of stickers. But it's far more than that. You've allowed me to be myself and to do my thing at my own speed. You helped me take chances, let me fail graciously, and have supported and grown with me over the last decade. Most importantly, you believed in me and this message.

To my partner Kat, who calmly stands by my side in the chaos, quietly and strongly offering her bold support.

To my son Dylan, who is the bravest and wildest burst of energy, constantly reminding me to be myself, with complete disregard for what anyone thinks.

To my parents, who have supported me through every step, in their own way — who, since they don't trust the internet, sent me a check to back this Kickstarter.

To my sister Sarah, who bought ten copies of this book, thousands of stickers, and many pieces of my work over the years. (Even when I insisted I would be happy to give them to her.)

To Firebelly Design, my incredible extended family. To Dawn Hancock, Will Miller, and Nick Adam, whose belief in me is humbling. They waded through over 30,000 files, hundreds of stories, and countless rewrites.

To Shannon Downey, for pushing (often shoving and kicking) me to stand confidently behind my ideas, and to create the Kickstarter for this book.

To Victor Saad, who was there on the phone with encouragement right before I hit the green "launch" button, and was there with a cake pop when it was successful.

To Johnny Michael, for helping me navigate, edit, write and rewrite a decade of memories into a few short pages.

To Ben Skoda, for making sure every last detail was perfect, and came across the way it was intended.

To Oprah, the team at Super Soul Sunday, and the surrounding community for embracing this message and surrounding me with so much support.

To Seth Godin, for the constant inspiration and encouragement, and for giving me the opportunity to be in a new world where I can be myself and tell people what I'm up too.

Thank you all for being a friend.

To Alex, Ralph, Nick, Karl, Chris, Nate, Jeremy, Lee, Joseph, Travis, Eric, Joe, Chris, and David, who took huge risks with me and taught me the true nature of friendship, who would jump on a bike or a bus, or even a plane, meeting me in cities around the world. I knew without question you'd always have my back. Karl put it best one night after I twisted his arm on a great adventure: "I knew I couldn't stop you, and I wasn't going to let you do it alone."